PRECIOUS

DEDICATION TO ILLY, EMMA AND JACK

PHOTOGRAPHS BY
MELANIE DUNEA
AND
NIGEL PARRY

PRECIOUS

powerHouse Books
New York, NY

CONTENTS

eyes

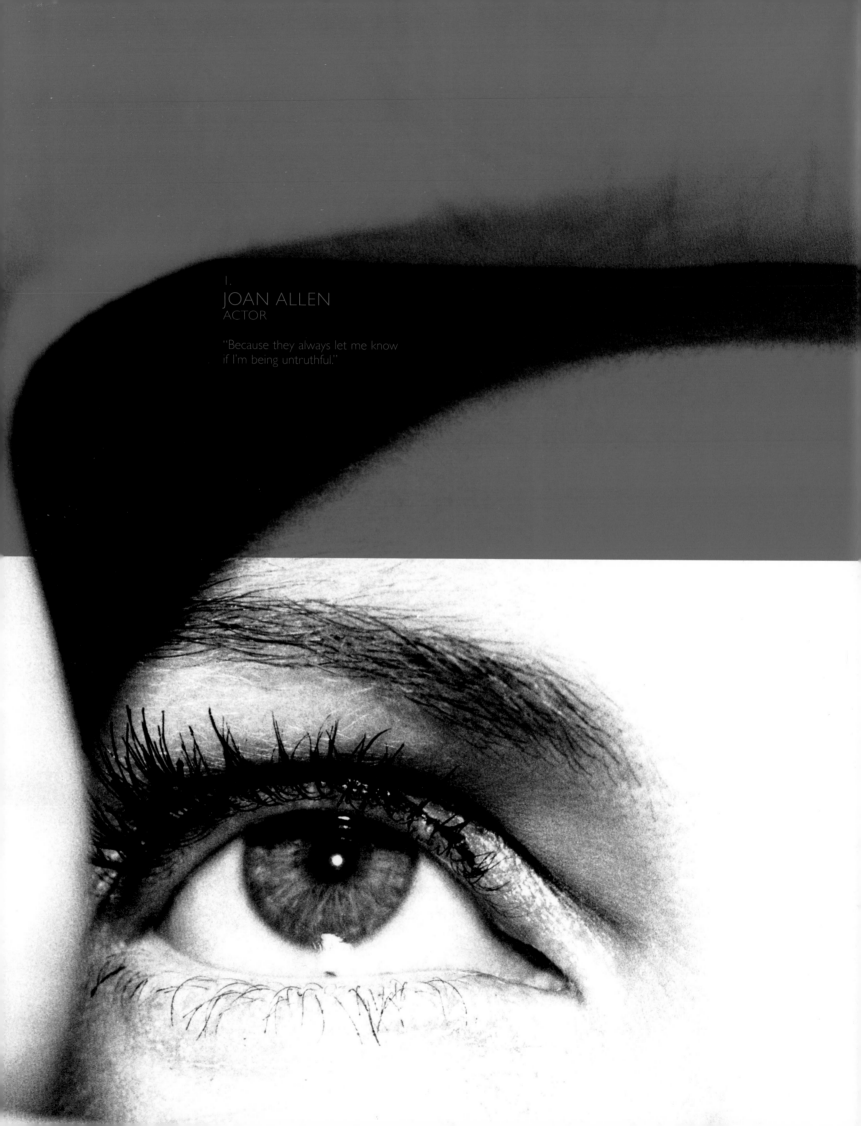

1.
JOAN ALLEN
ACTOR

"Because they always let me know
if I'm being untruthful."

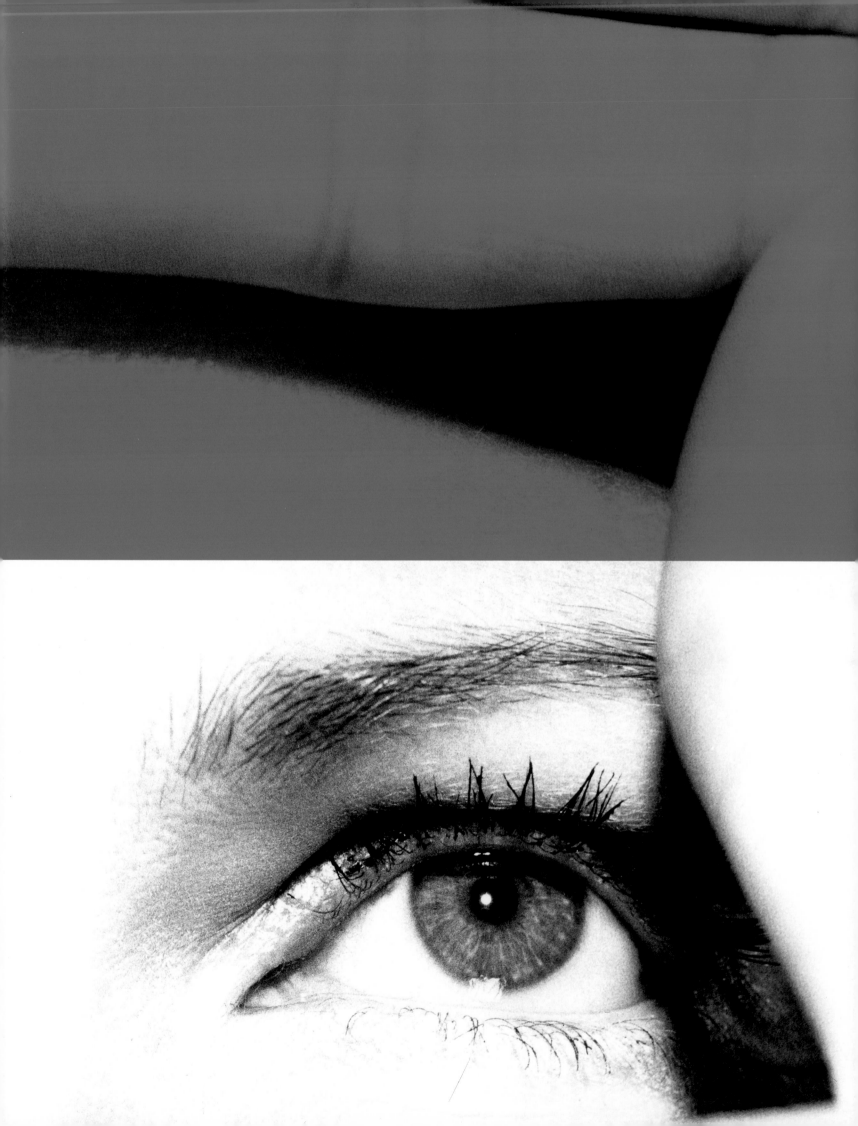

hands

heart

2.
ARNOLD SCHWARZENEGGER
GOVERNOR OF CALIFORNIA

"When Nigel asked me which was my favorite body part, I immediately said my brain, which is ultimately responsible for my drive and success. Since he could not photograph my brain, the next most important feature is my hands. The hands physically interpret the brain's commands and provide me with the strength and force to accomplish what my mind sets out to do."

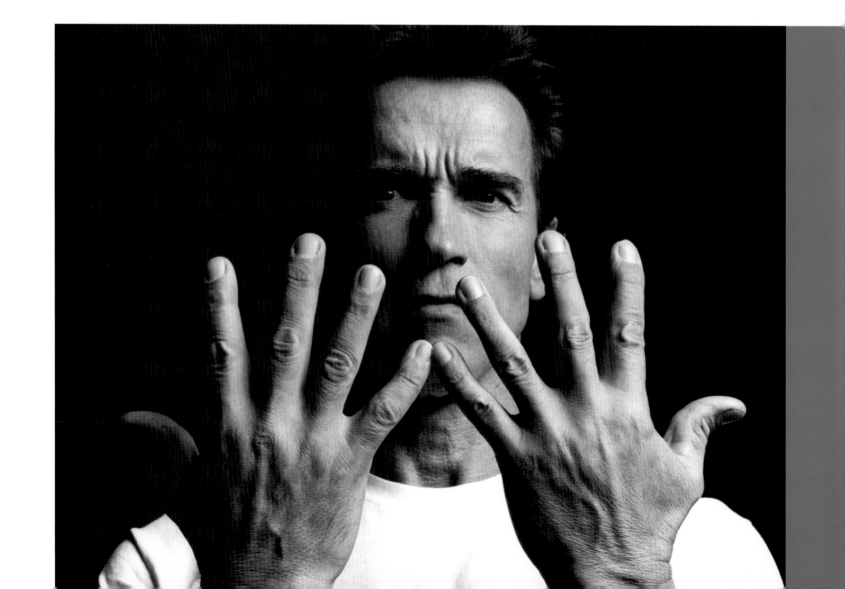

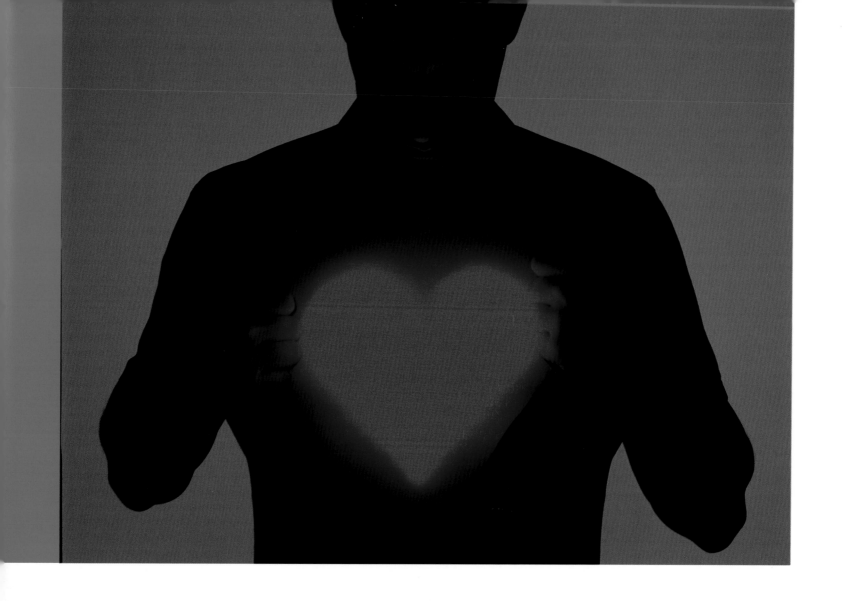

3.
ANDERSON COOPER
ANCHOR, CNN

"My heart is the most important part of my body for a couple of reasons. My dad died of a heart attack when I was ten, so as long as I can remember, I've been very aware of the power of this little organ. Even now, at night, I sometimes lie awake, listening to my heart, amazed that the rest of my body depends on its strange rhythm. I'm very protective of my little heart, and I hope to keep it beating for as long as I can."

tongue

smile

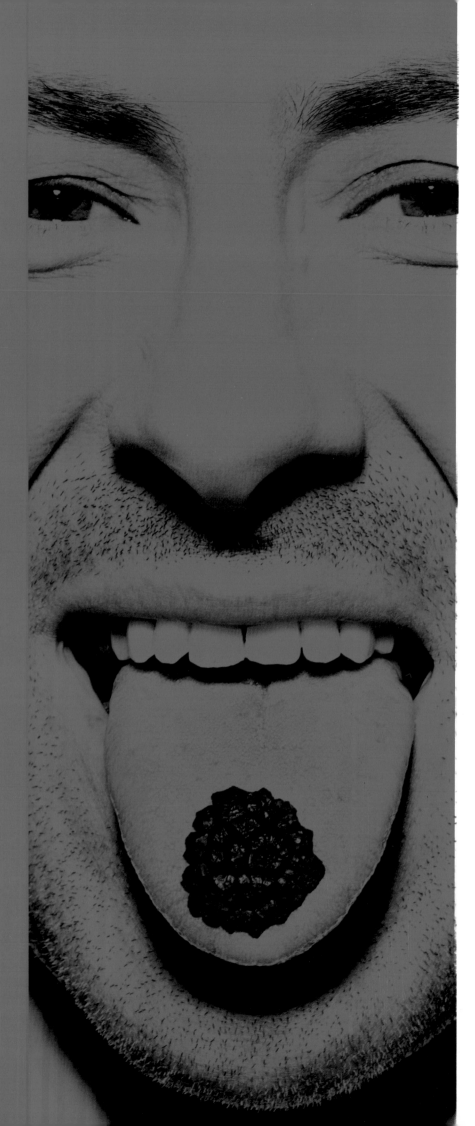

4.
DANIEL BOULUD
CHEF

"Yumm, c'est bon."

5.
MARISKA HARGITAY
ACTOR

"If the eyes are the window of the soul, the smile is the soul's expression."

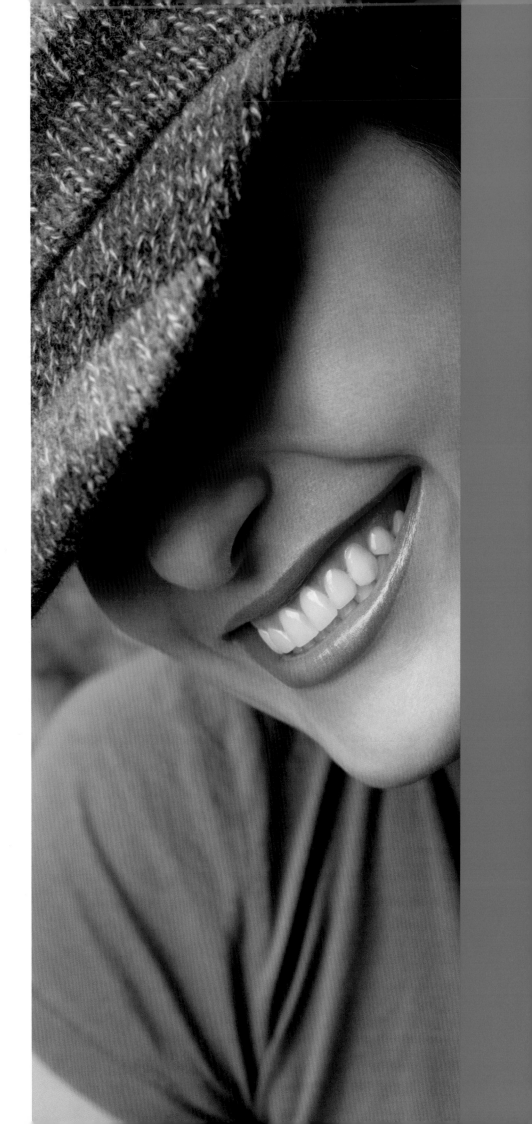

feet

feet

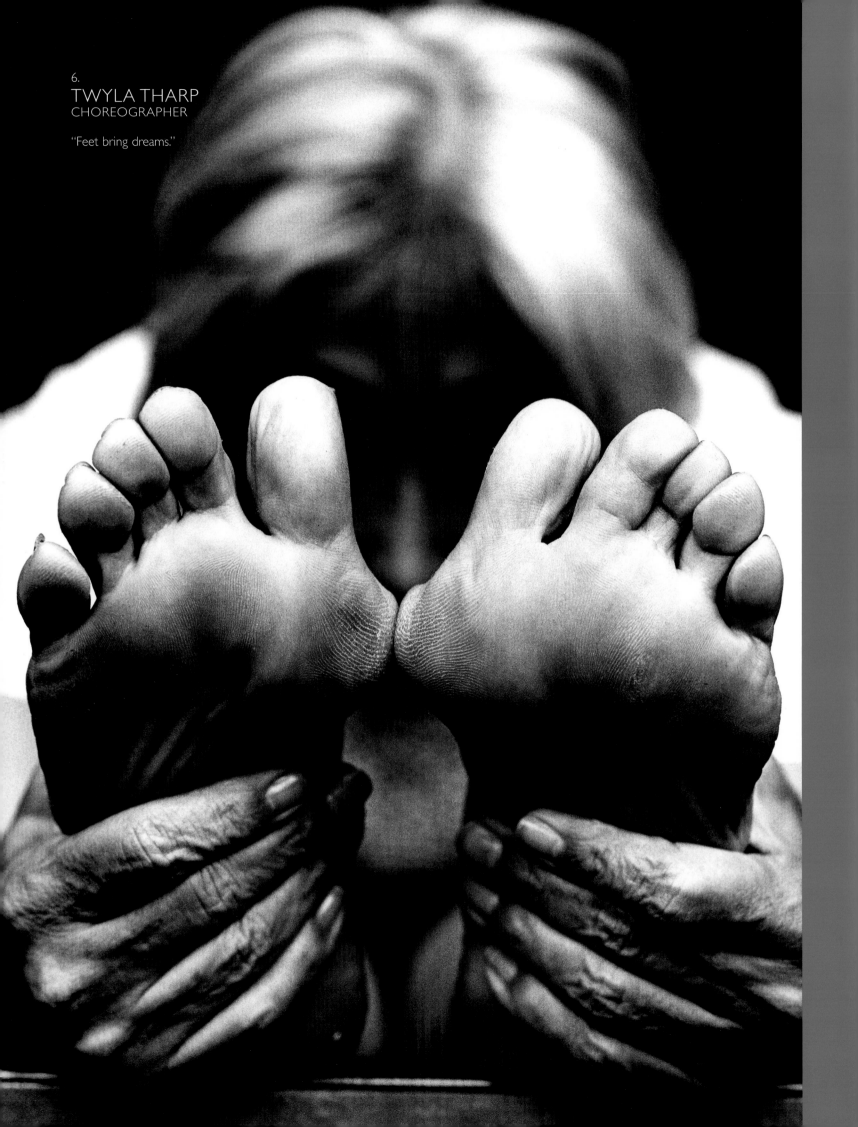

6.
TWYLA THARP
CHOREOGRAPHER

"Feet bring dreams."

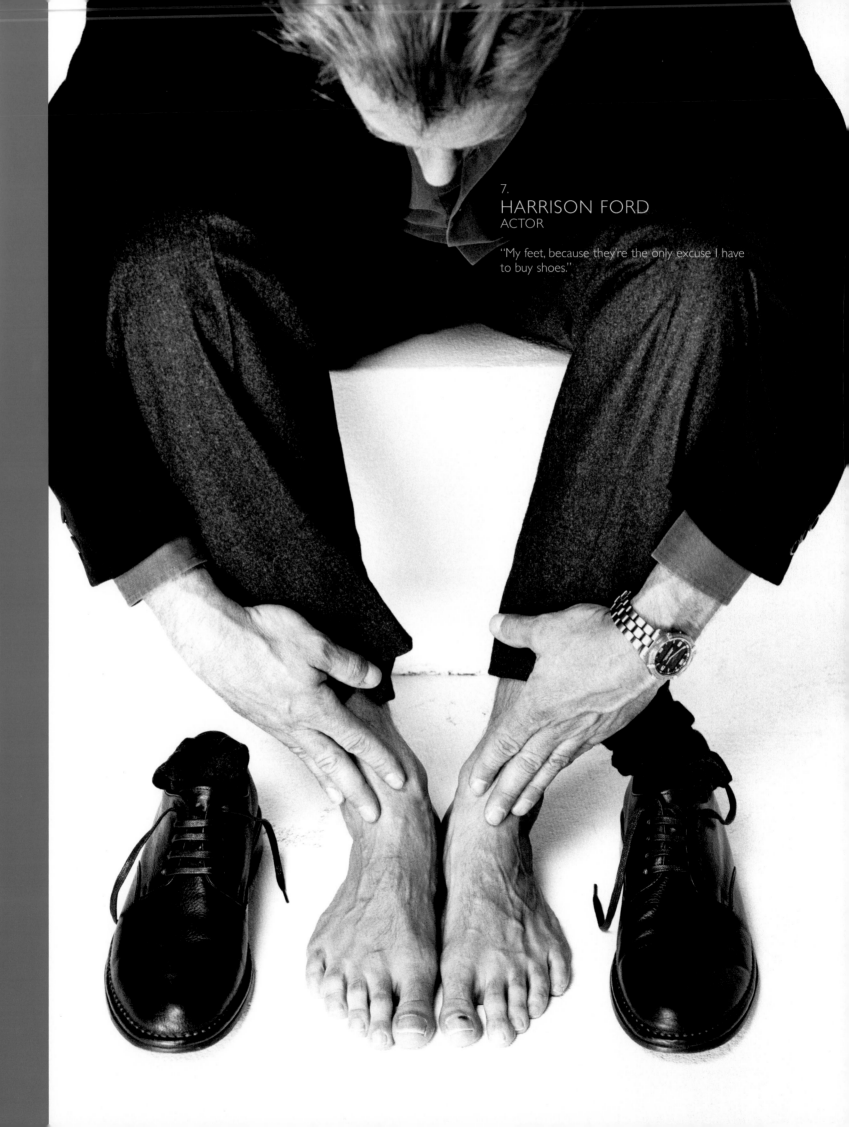

7.
HARRISON FORD
ACTOR

"My feet, because they're the only excuse I have to buy shoes."

mouth

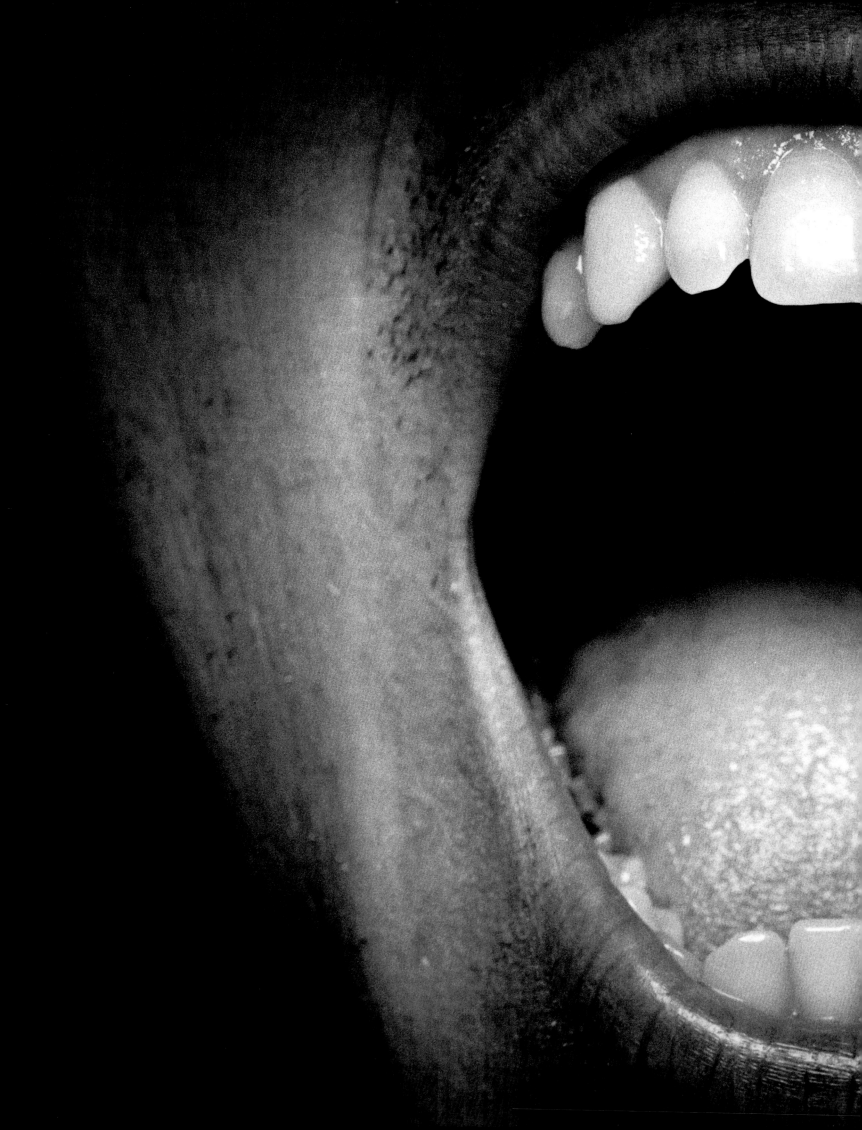

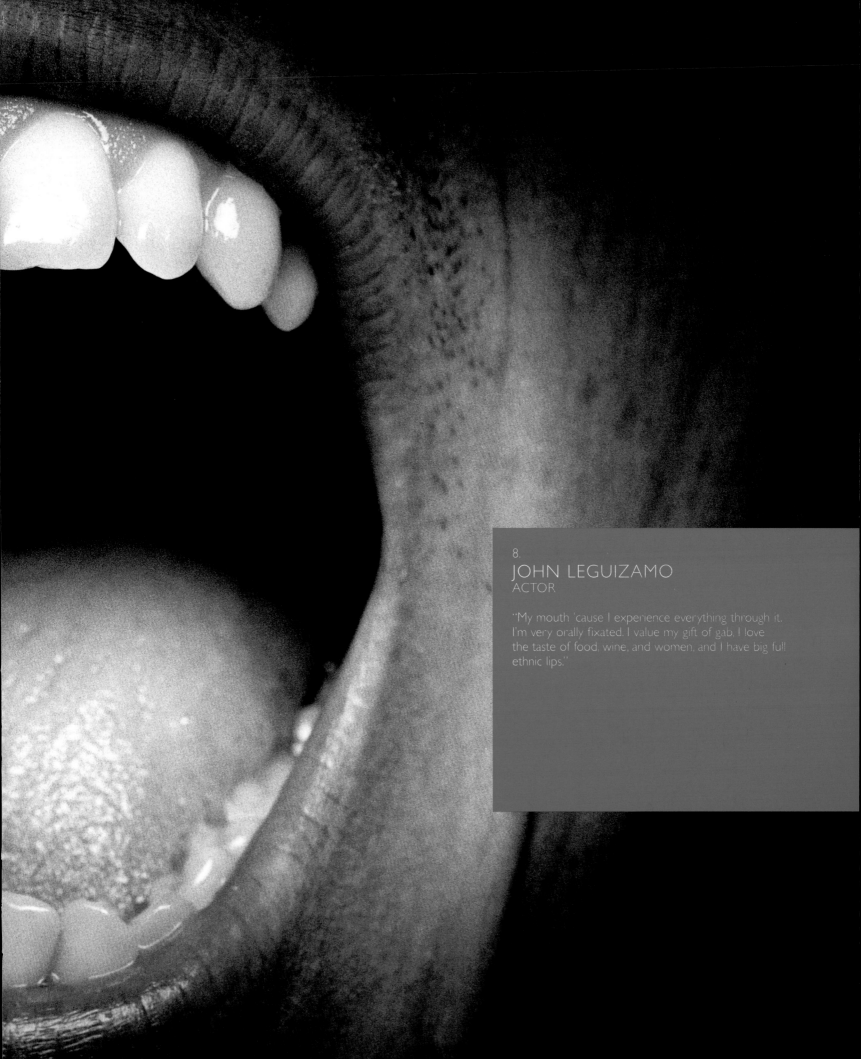

8.

JOHN LEGUIZAMO
ACTOR

"My mouth 'cause I experience everything through it.
I'm very orally fixated. I value my gift of gab, I love
the taste of food, wine, and women, and I have big full
ethnic lips."

belly button

family

9.
DOMINIC MONAGHAN
ACTOR

"The tube that was once coming out of this hole
kept me alive when I was small, blind, and hungry.
It deserves to be acknowledged."

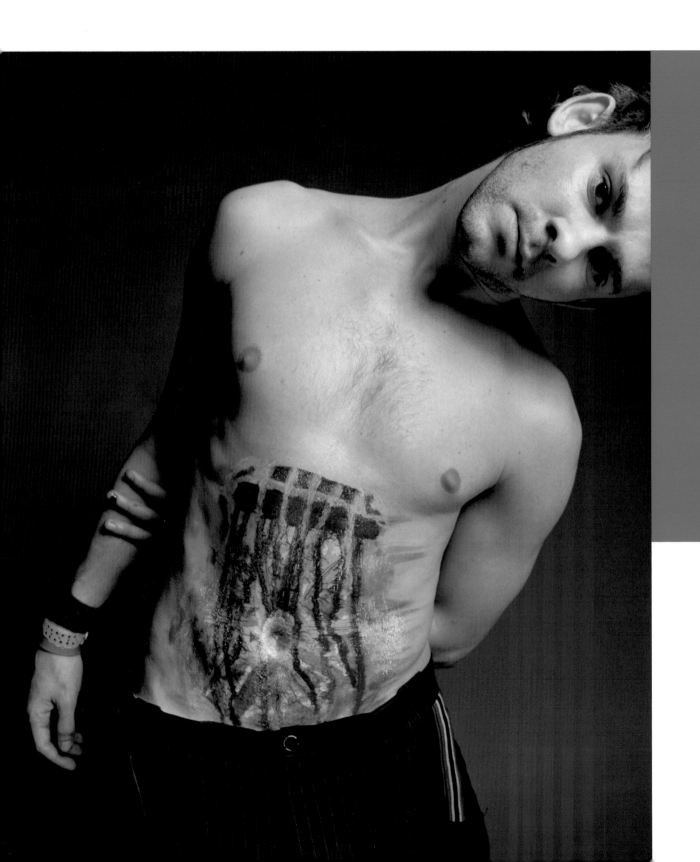

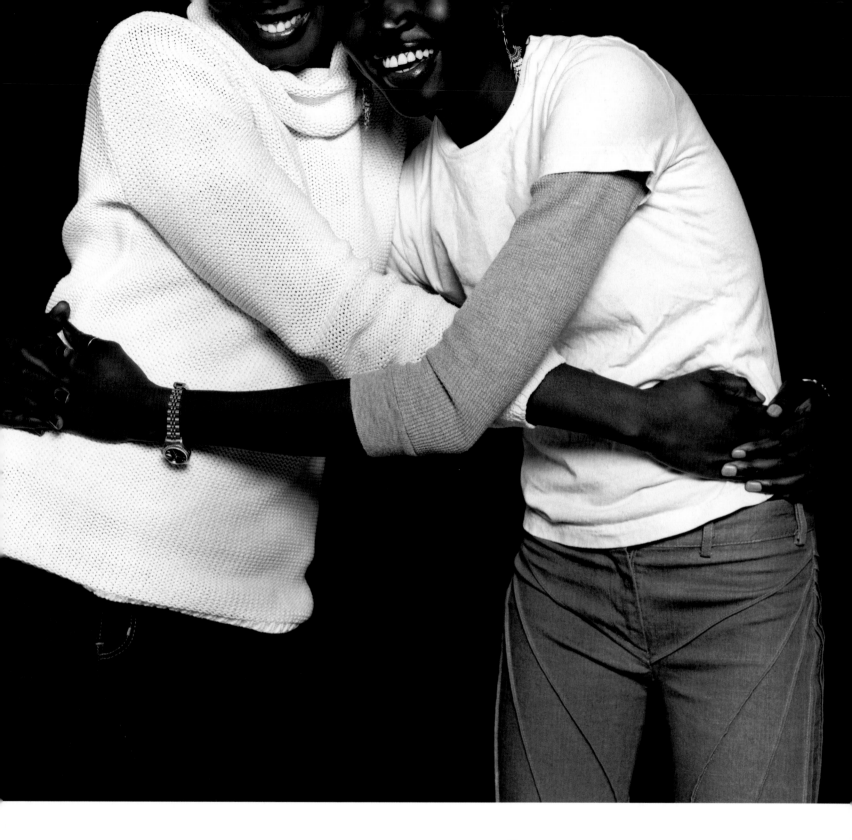

10.
ALEK WEK
MODEL

"My family makes me feel safe and lots of love."

legs

legs

11.

DIANE VON FURSTENBERG
DESIGNER

"I choose my legs...because I can rely on them."

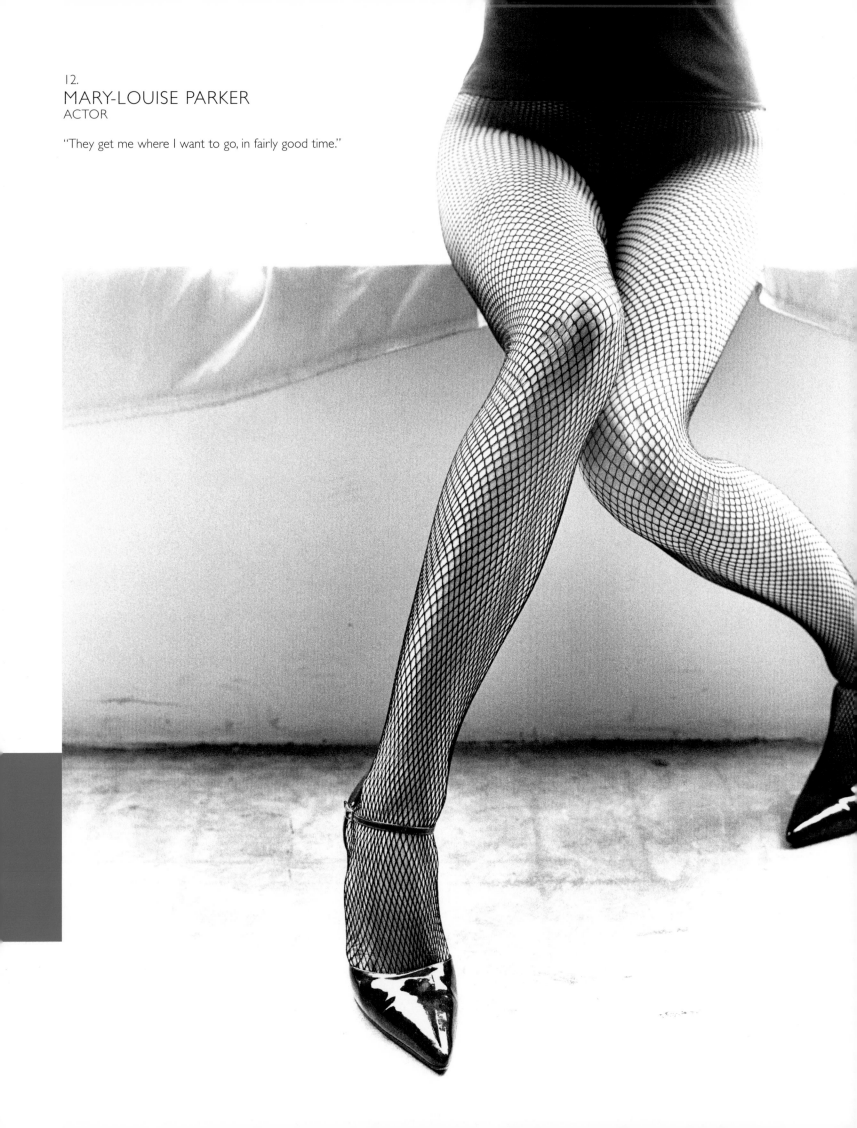

12.
MARY-LOUISE PARKER
ACTOR

"They get me where I want to go, in fairly good time."

breath

13.
JOHNNY DEPP
ACTOR

"Breath. We tend not to think much about it.
We somehow take it for granted. Each one is a
blessing—every inhale, every exhale. When it stops…
we're done. It's over with."

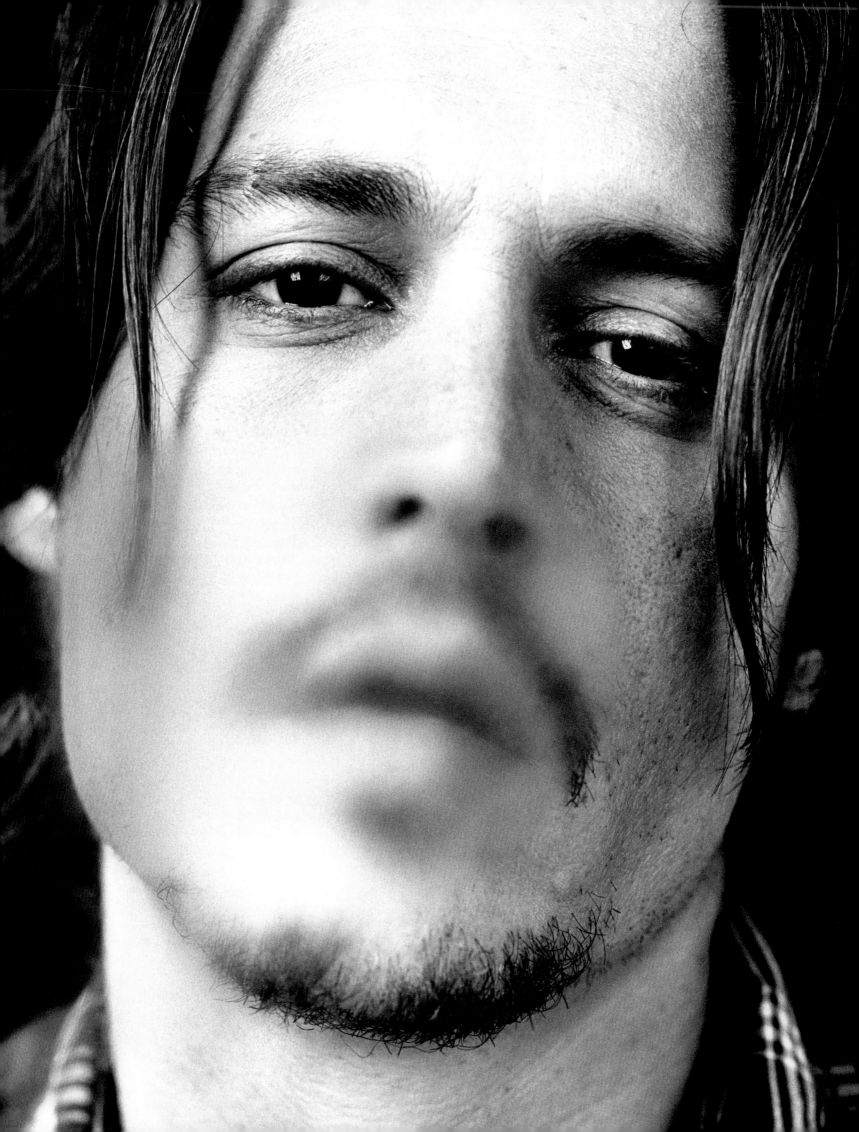

feet

eyes

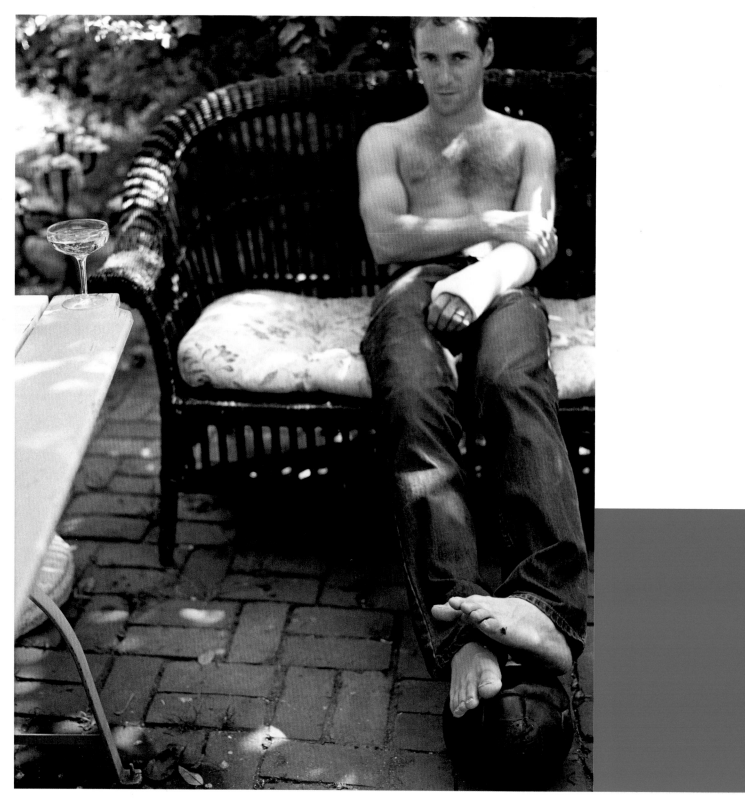

14.

ALESSANDRO NIVOLA
ACTOR

"Oh man, these feet got silky skills!"

15.

KEVIN VENARDOS
RINGMASTER, RINGLING BROS. AND BARNUM &
BAILEY™—THE GREATEST SHOW ON EARTH™

"The ringmaster is the heart of the circus.
Here, things sparkle, somersault, and even explode.
But look in our eyes—it is our love and amazement
for the great feats humans can achieve that have
shown me incredible things. Through war, depression,
and uncertainty, THE SHOW MUST GO ON!"

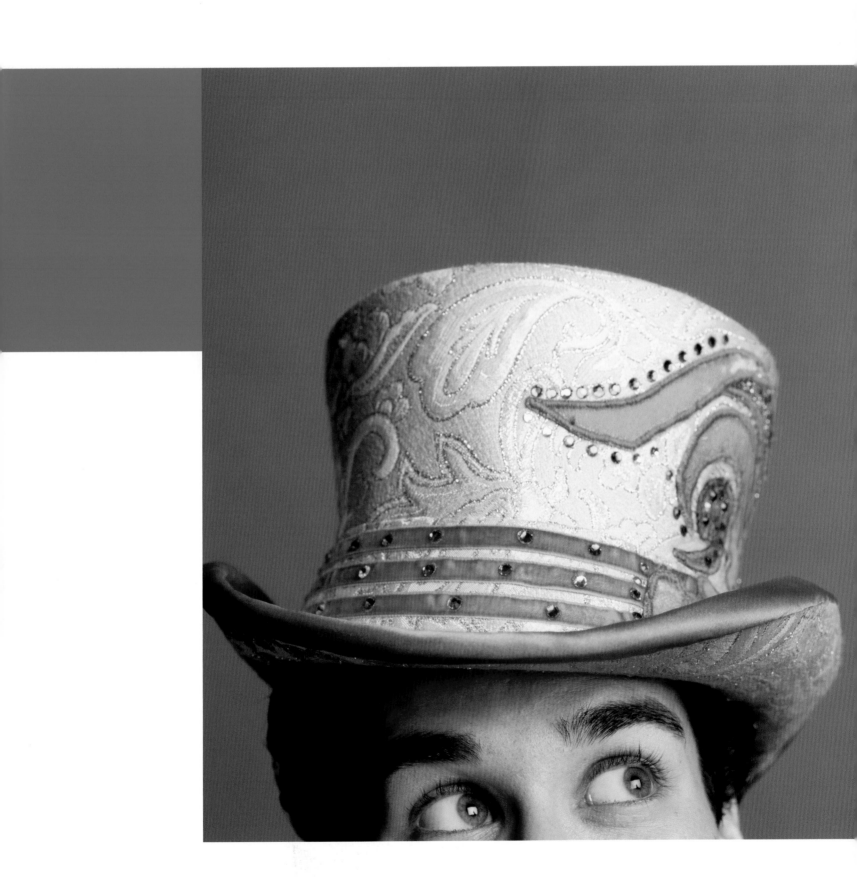

ankles

shins

16.

AUDREY QUOCK
MODEL

"My ankles are my favorite body part because no matter how chubby I get, they never gain any weight."

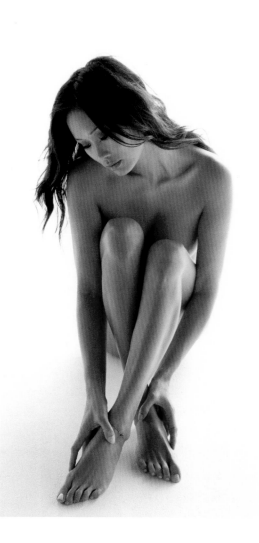

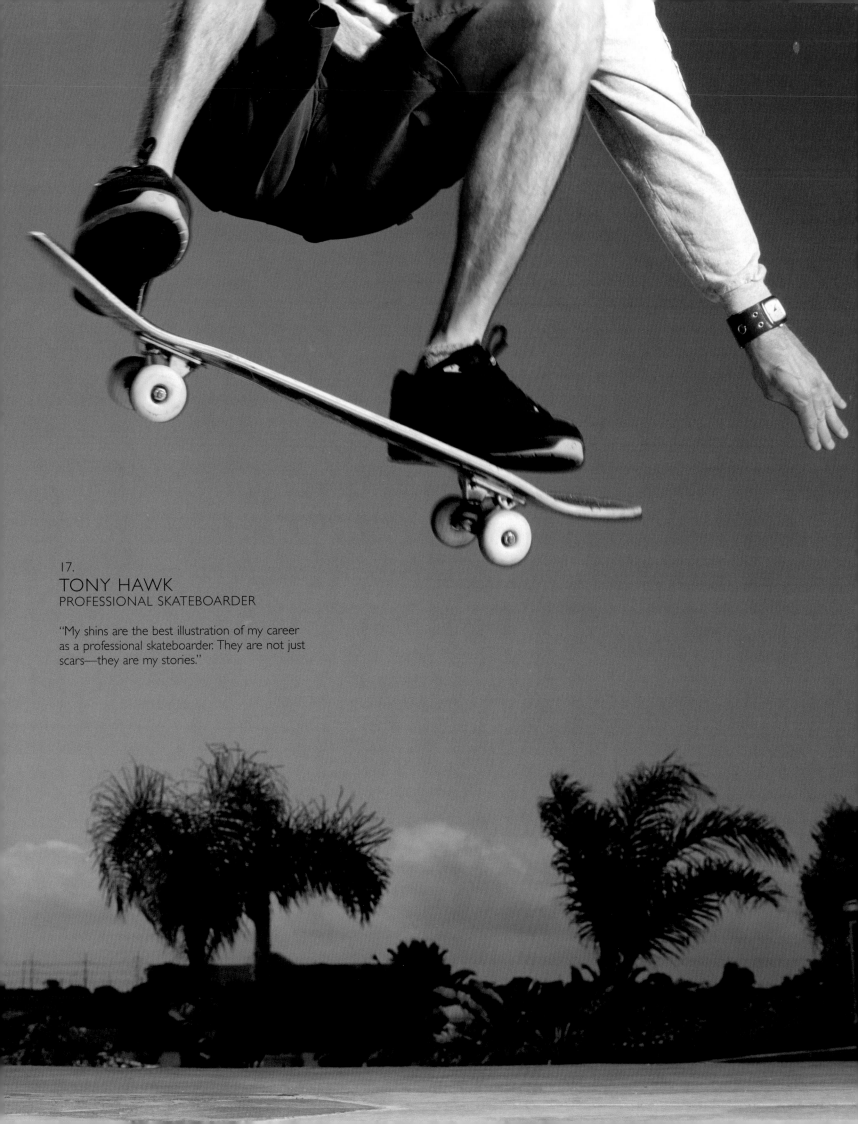

17.
TONY HAWK
PROFESSIONAL SKATEBOARDER

"My shins are the best illustration of my career
as a professional skateboarder. They are not just
scars—they are my stories."

finger tips

hair

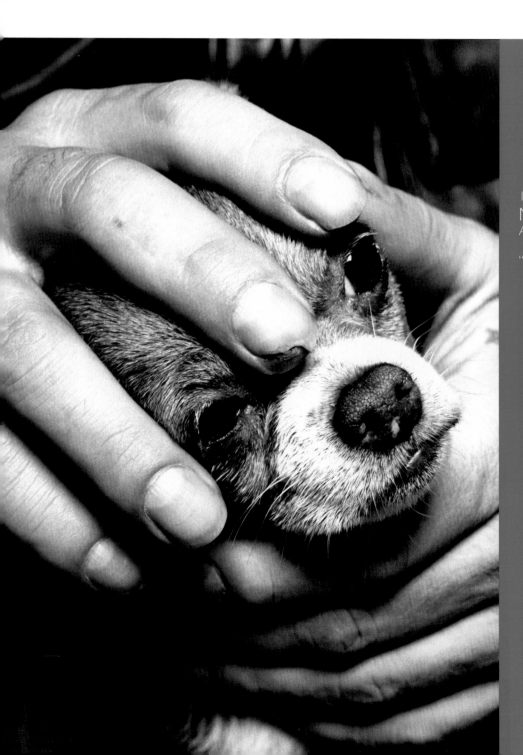

18.
MICKEY ROURKE
ACTOR

"Finger tips—I love to stroke my dog."

19.
PAUL GIAMATTI
ACTOR

"My hair is a very precious commodity."

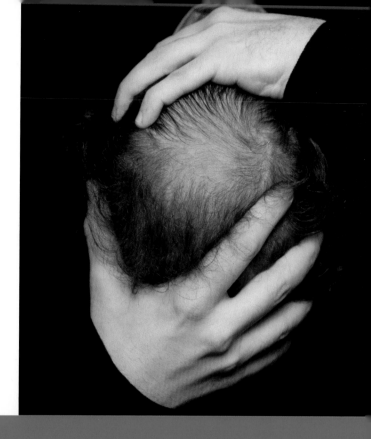

shoulders

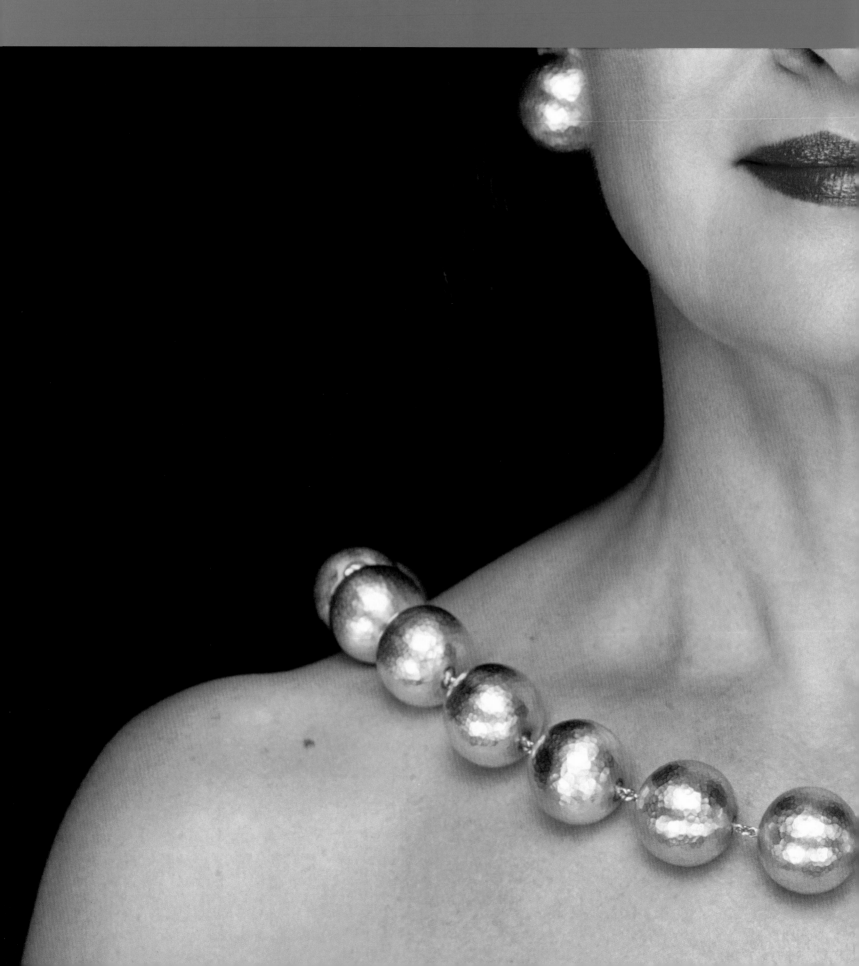

20.
PALOMA PICASSO
DESIGNER

"My shoulders, because they are my husband's
favorite too."

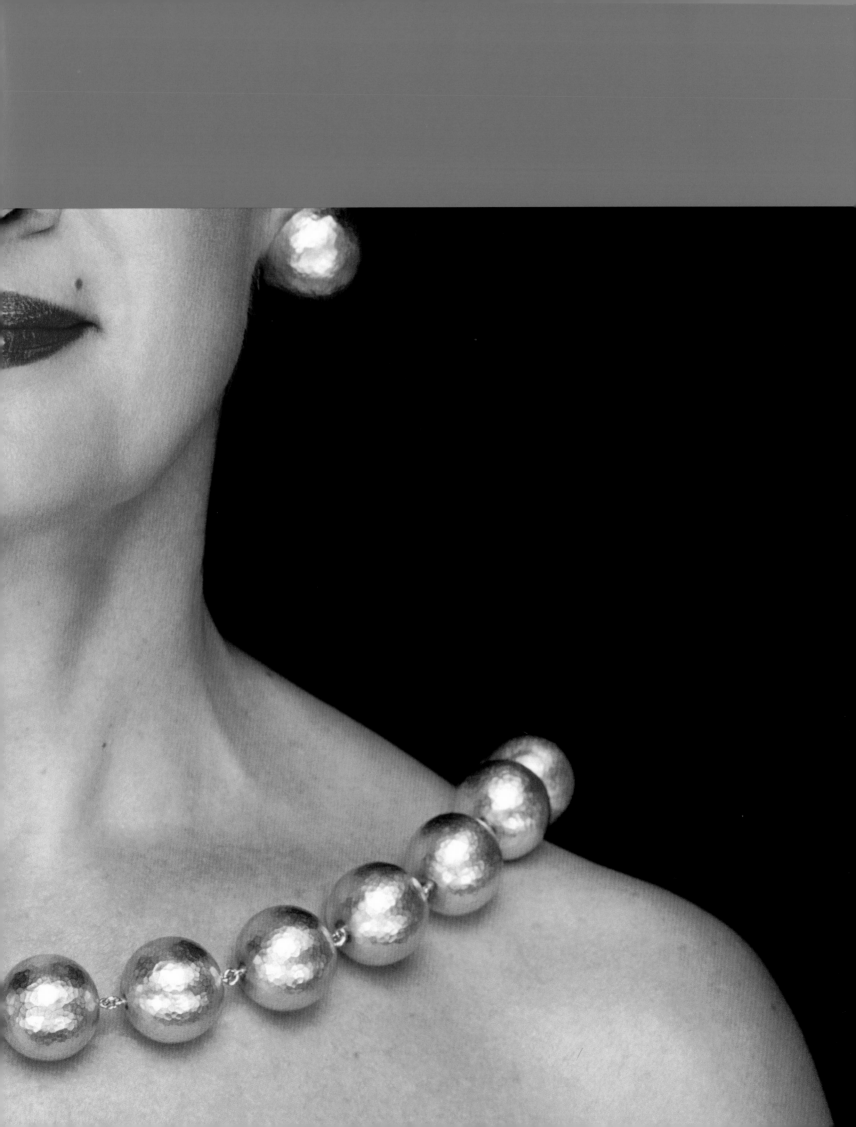

shoulders

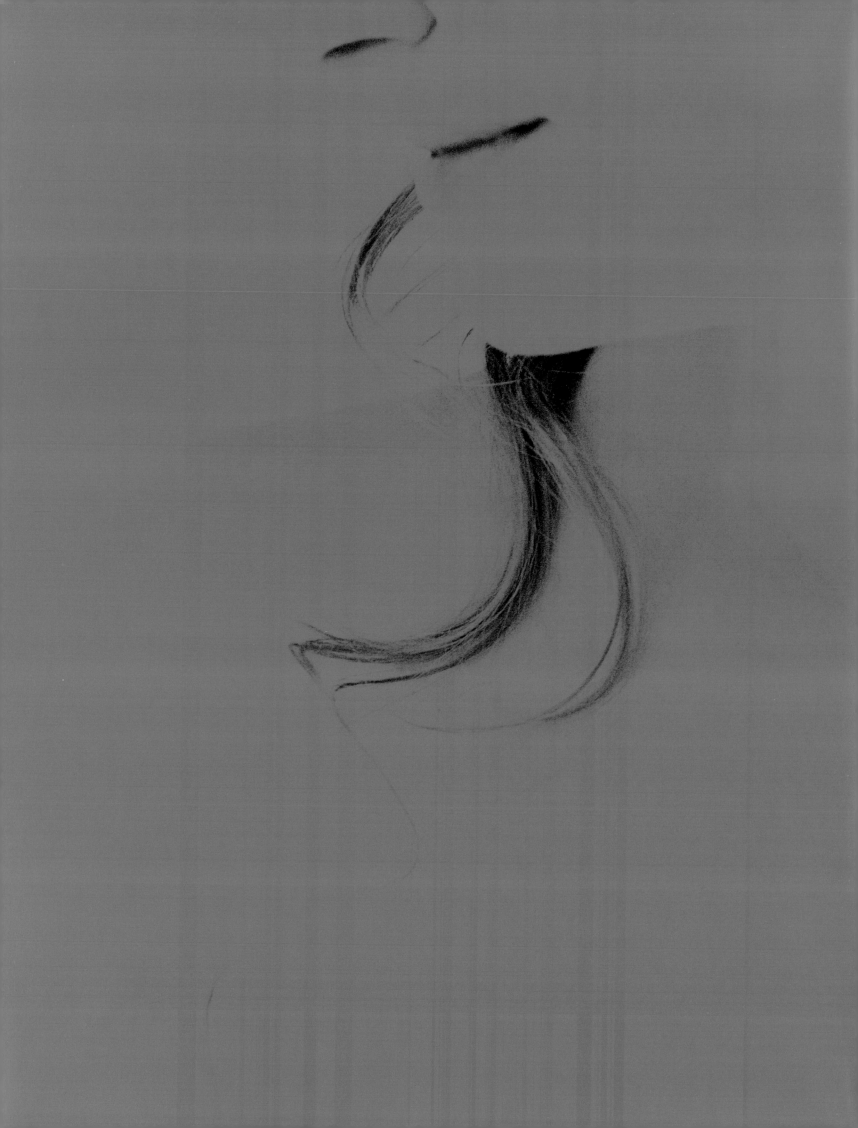

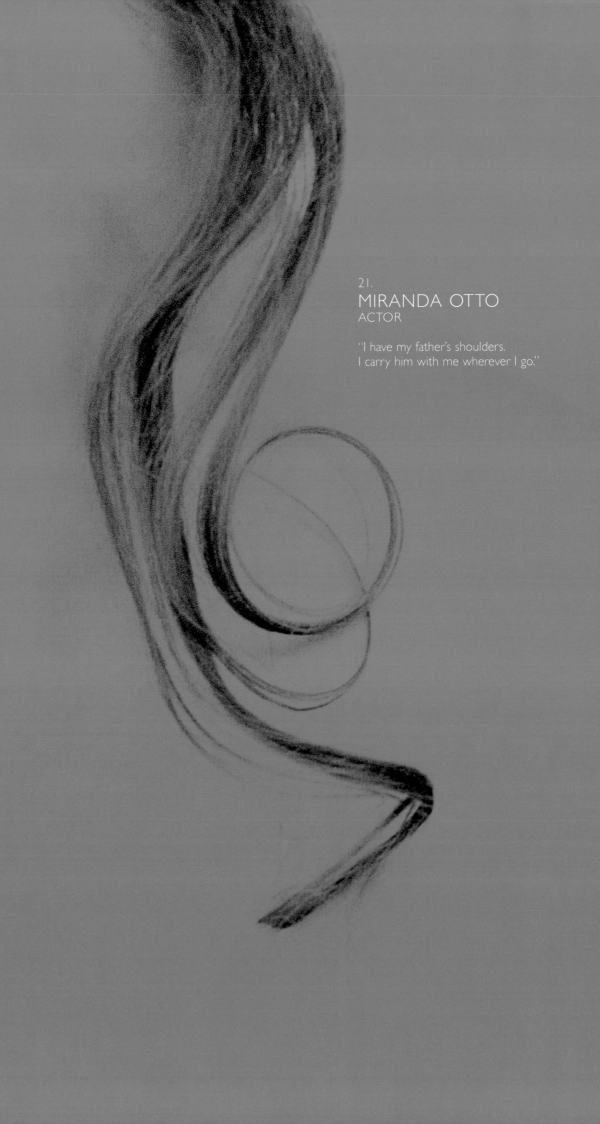

21.
MIRANDA OTTO
ACTOR

"I have my father's shoulders.
I carry him with me wherever I go."

nose

breast

22.
DOMINIC CHIANESE
ACTOR

"My nose reminds me of my grandfather:
Domenico Chianese."

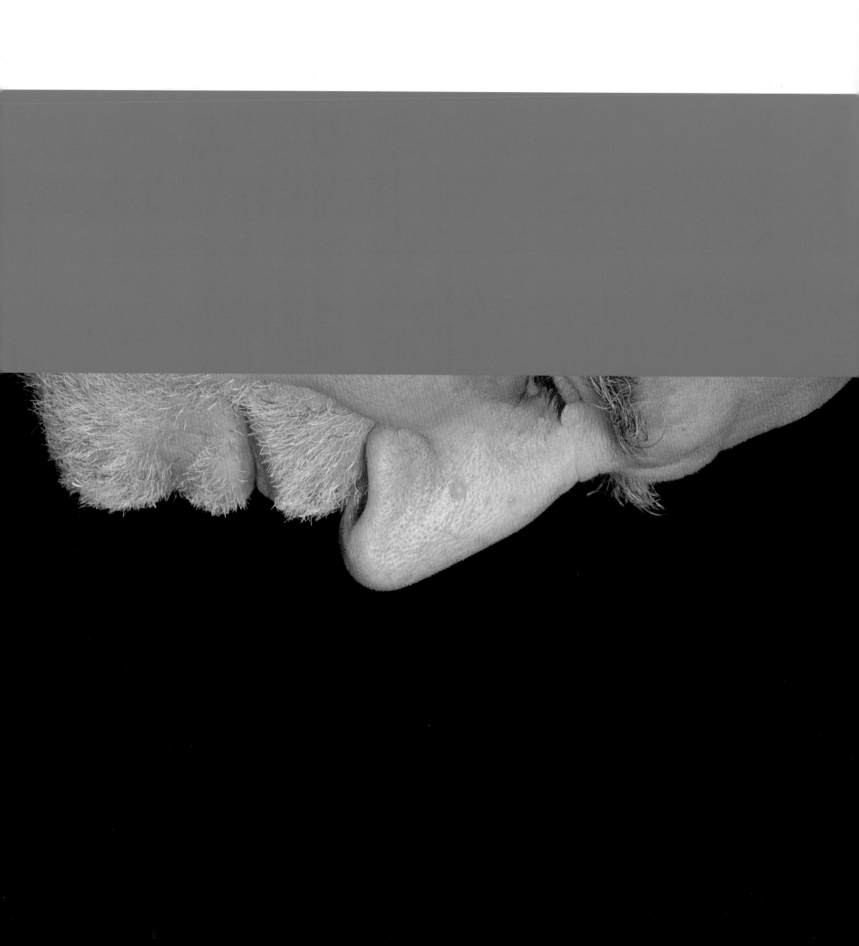

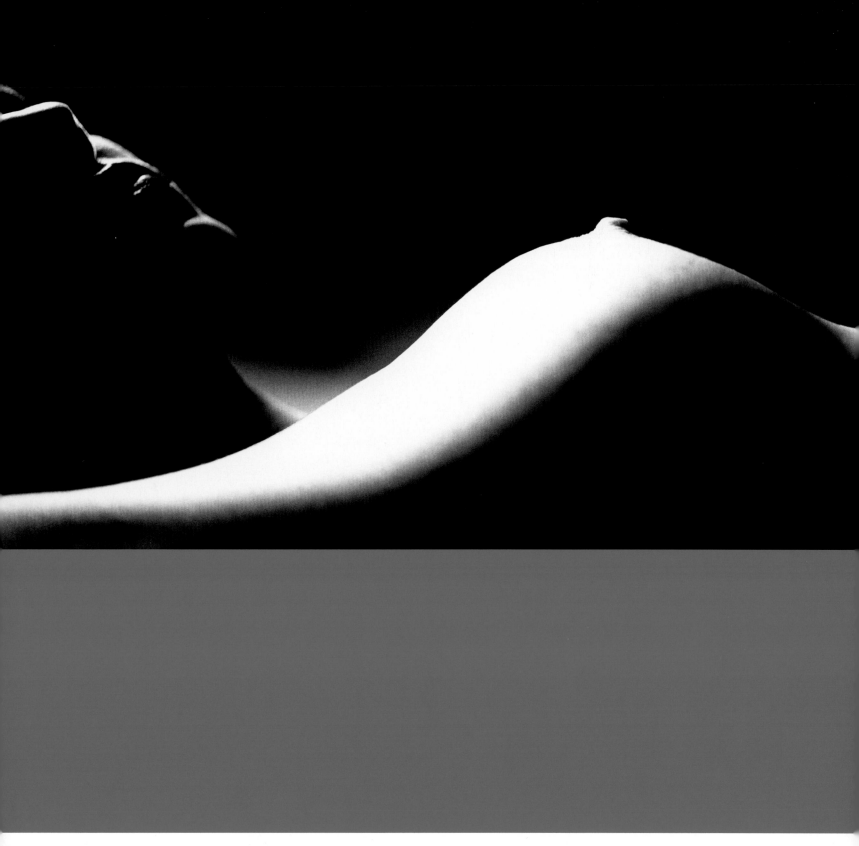

23.
POPPY MONTGOMERY
ACTOR

"Sensuality, sexuality, nurturing, nourishing, mother-hood, womanhood, precious."

eyes

24.
DR. MEHMET OZ
CARDIOLOGIST

"The opposing thumb allows the usual dexterity required to fix ailing hearts and symbolizes the unity and wholeness embodied in this most precious of organs."

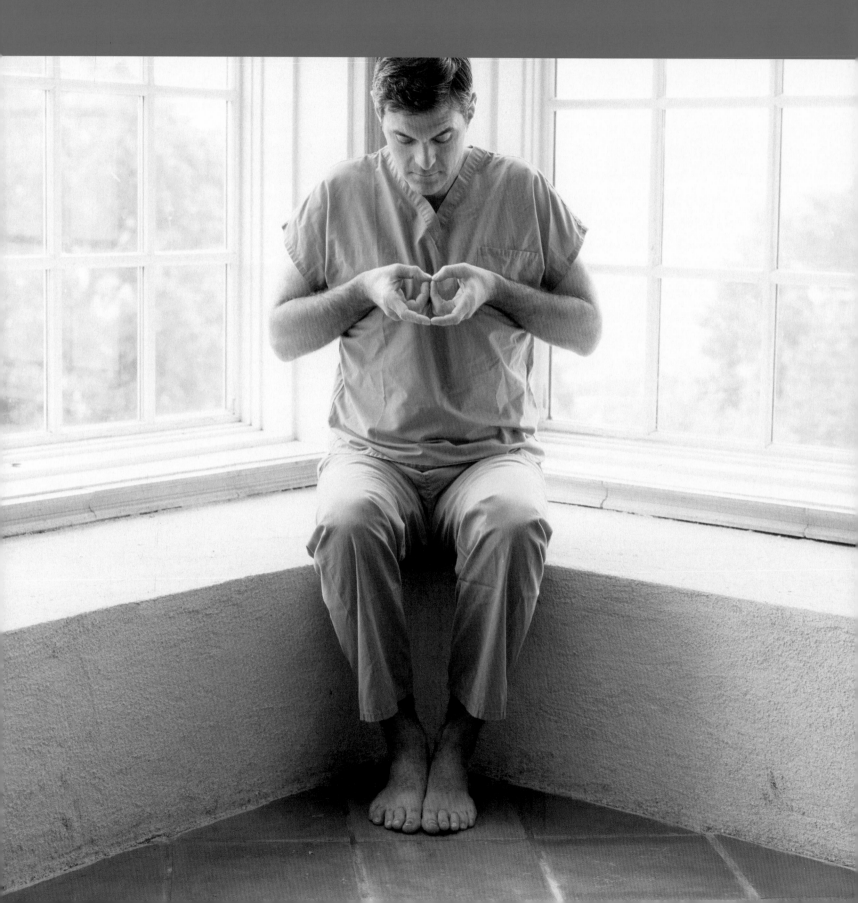

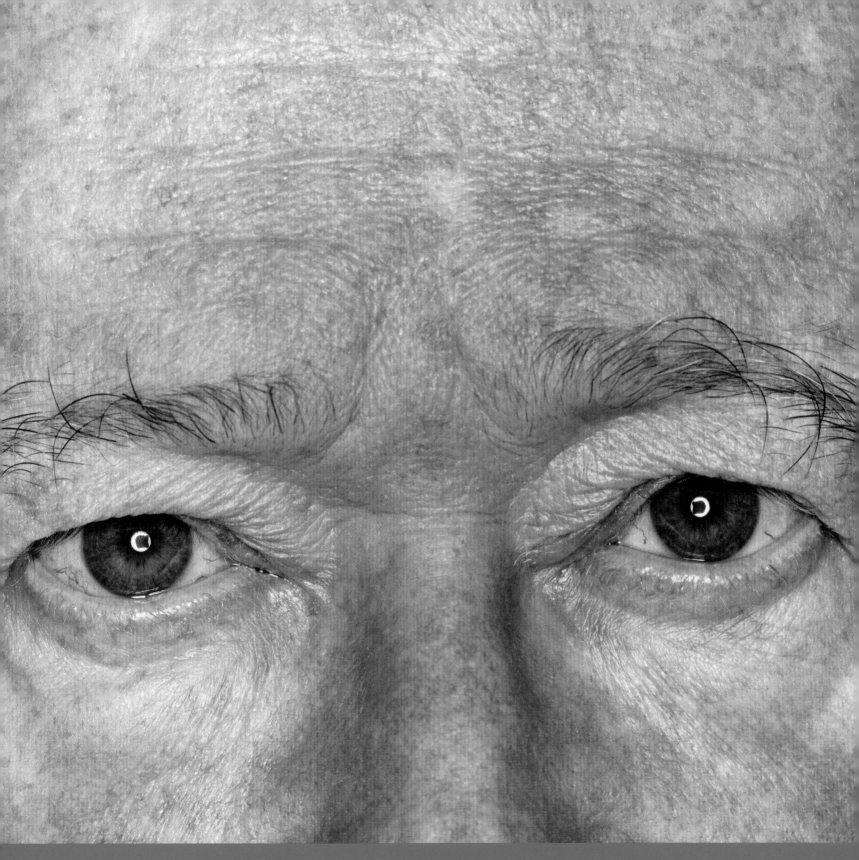

25.
ED KOCH
105TH MAYOR OF NEW YORK CITY

"The eyes reflect the soul within."

pinky rings and hair

lips

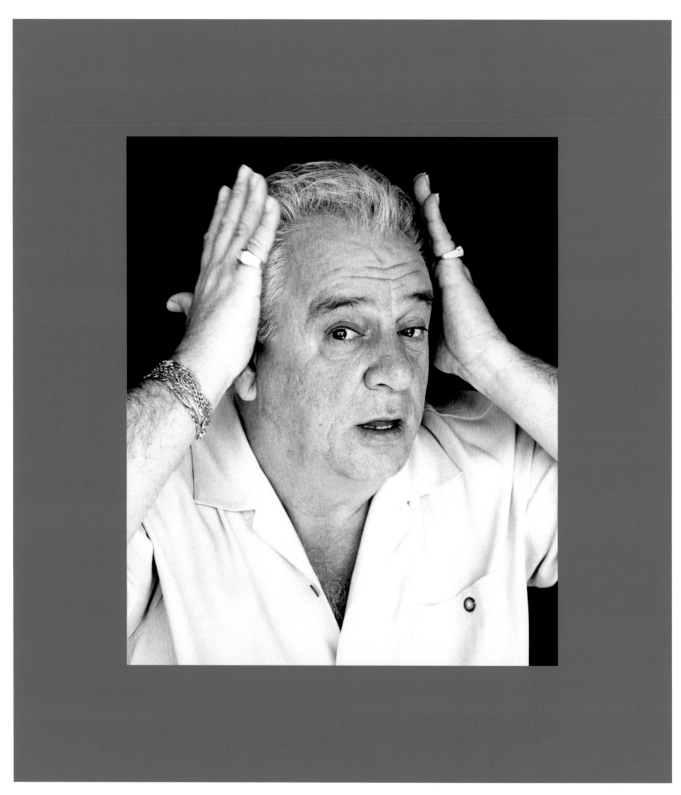

26.

VINNY VELLA, SR.
ACTOR

"My pinky rings, 'diamonds,' and my hair."

JUDITH REGAN
PUBLISHER

"hello"

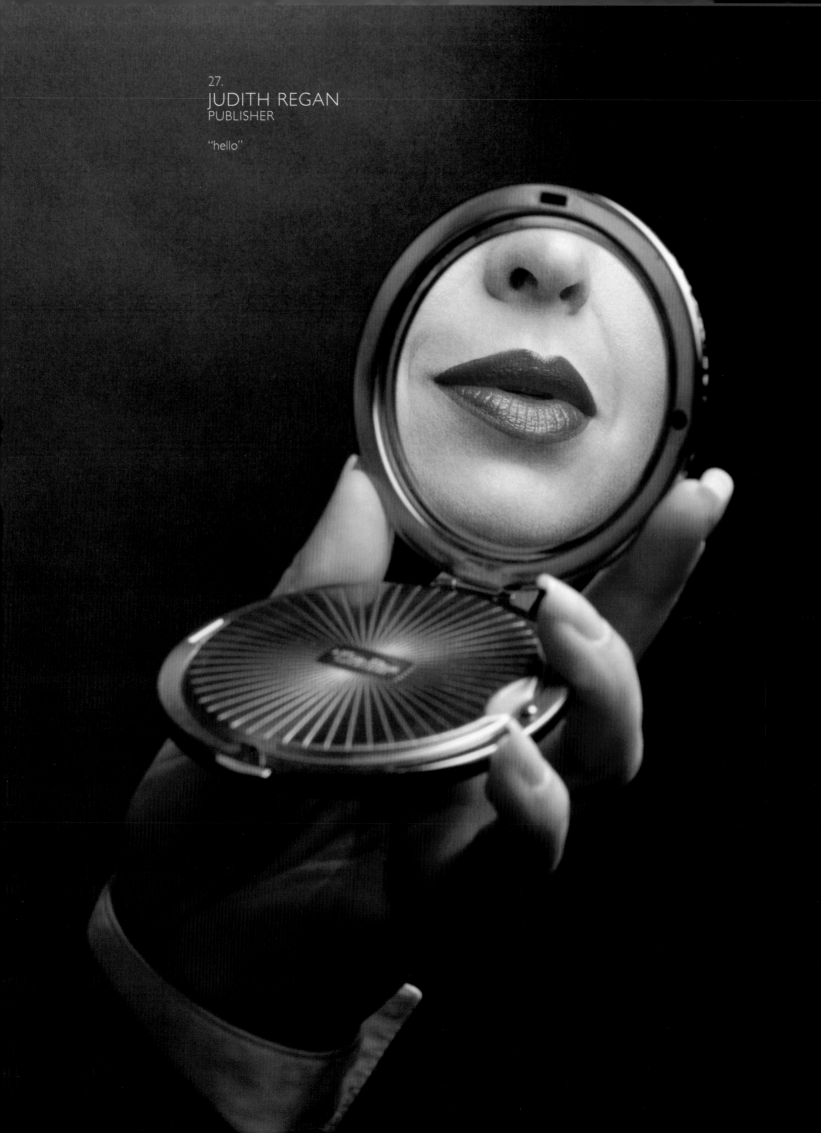

skin

smile

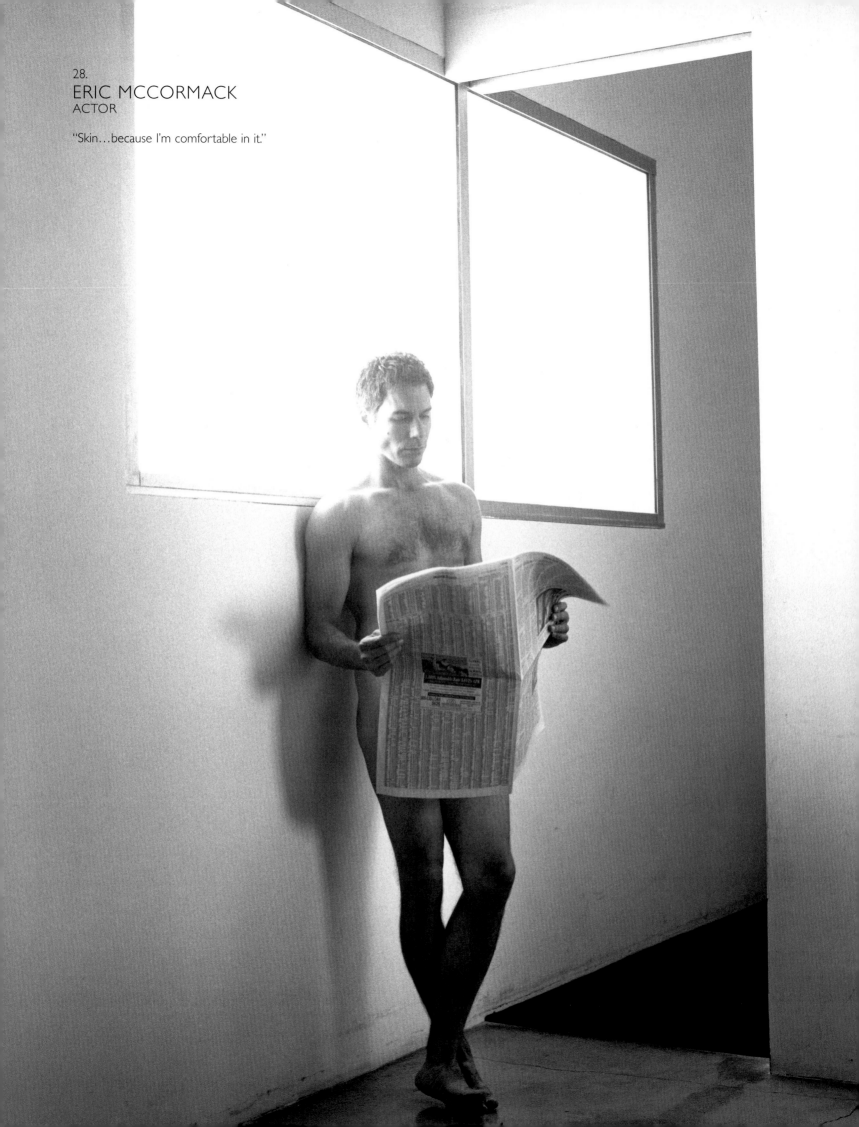

28.
ERIC MCCORMACK
ACTOR

"Skin…because I'm comfortable in it."

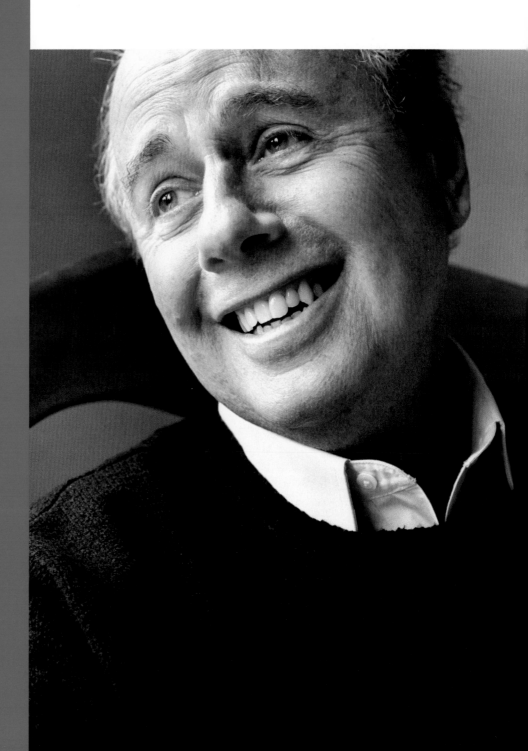

29.
ROGER ROSENBLATT
AUTHOR

"My smile—as you can see—is warm, attentive, and definitely precious, and aggressively insincere. I wear it for every social occasion in my life, of which there are very few, and at which I am totally inept. People try to talk to me at parties, and I smile my smile. Here's what I'm thinking: Where can I erect the gallows?"

hands

hands

30.
MICHAEL PANES
ACTOR

"p.s. I love you."

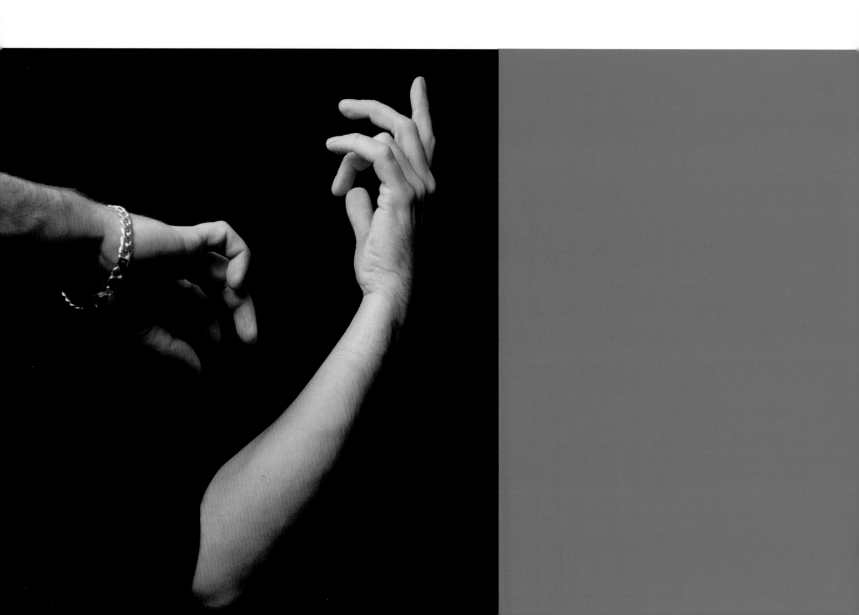

31.
EDIE FALCO
ACTOR

"As a kid growing up, I hated my hands because they were big and strong and mannish. There was nothing feminine about them. As I became an adult, I grew to accept them because they are uniquely my own."

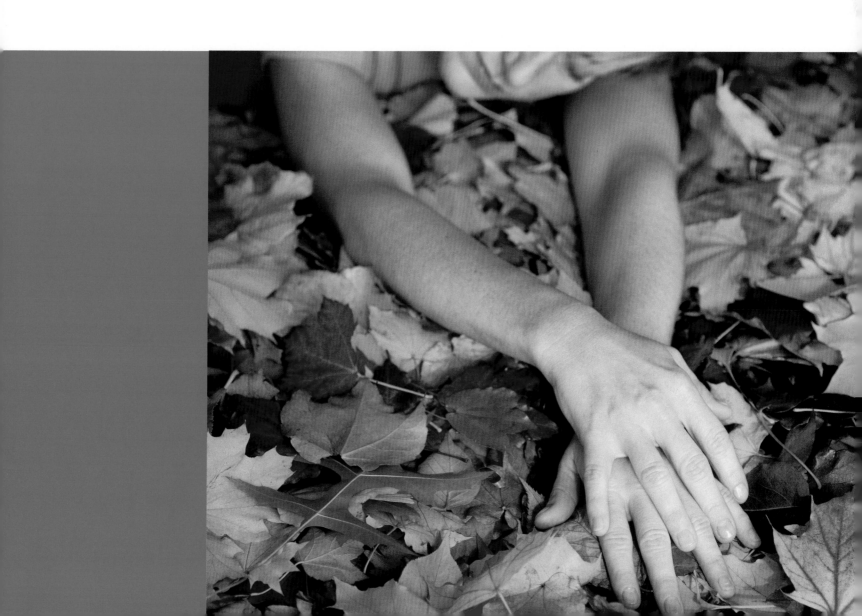

thumb

hand

32.
JUSTUS OEHLER
GRAPHIC DESIGNER

"I love the thumbs-up sign; I like things to be OK.
Fancy the yin-yang on my thumb?"

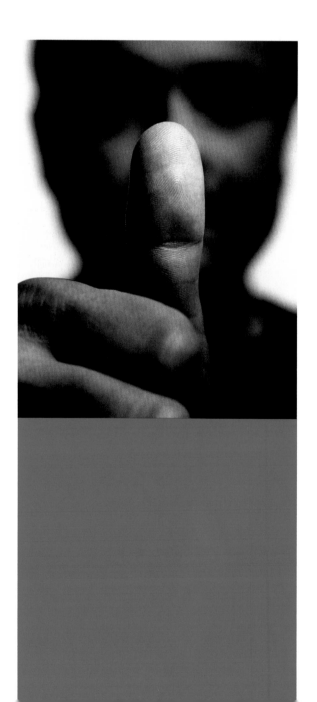

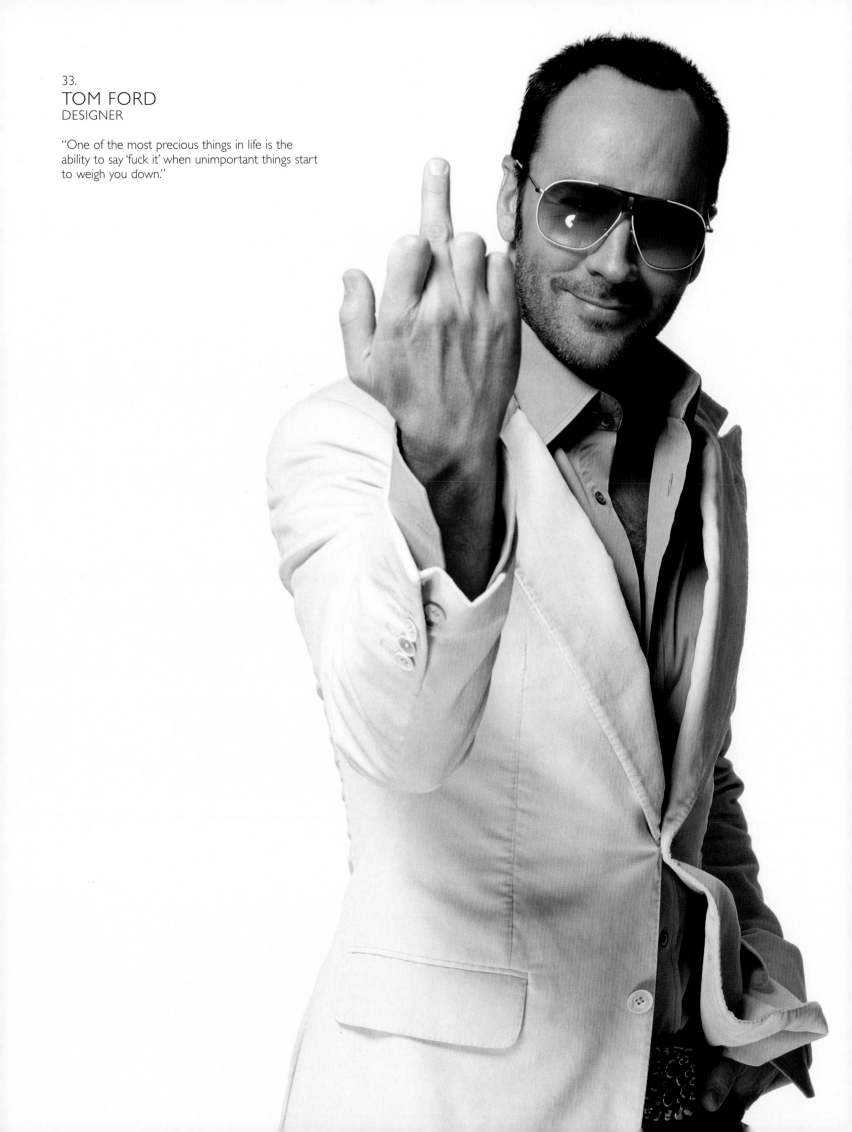

33.
TOM FORD
DESIGNER

"One of the most precious things in life is the ability to say 'fuck it' when unimportant things start to weigh you down."

palms

hands

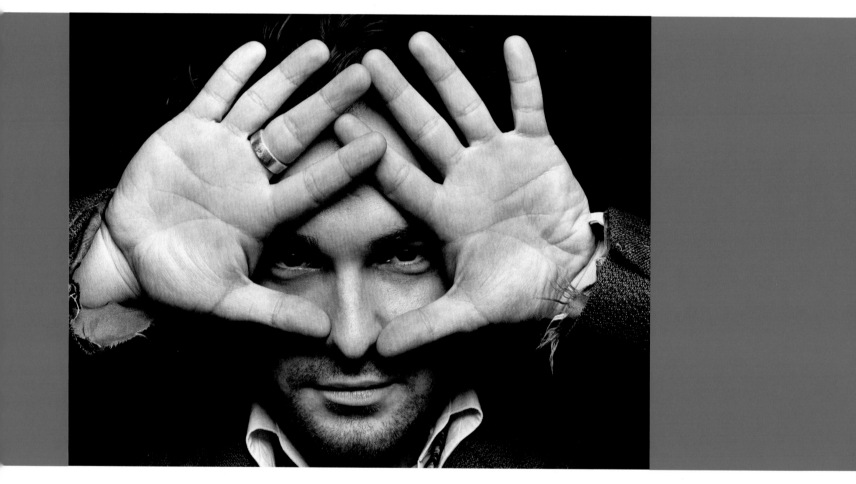

34.
JOHNNY GALECKI
ACTOR

"…Because…."

35.
STANLEY TUCCI
ACTOR

"I chose my hands because I think it's my best feature.
I inherited my father's hands, which are beautiful
hands. My family has always worked with their hands
as artisans or artists."

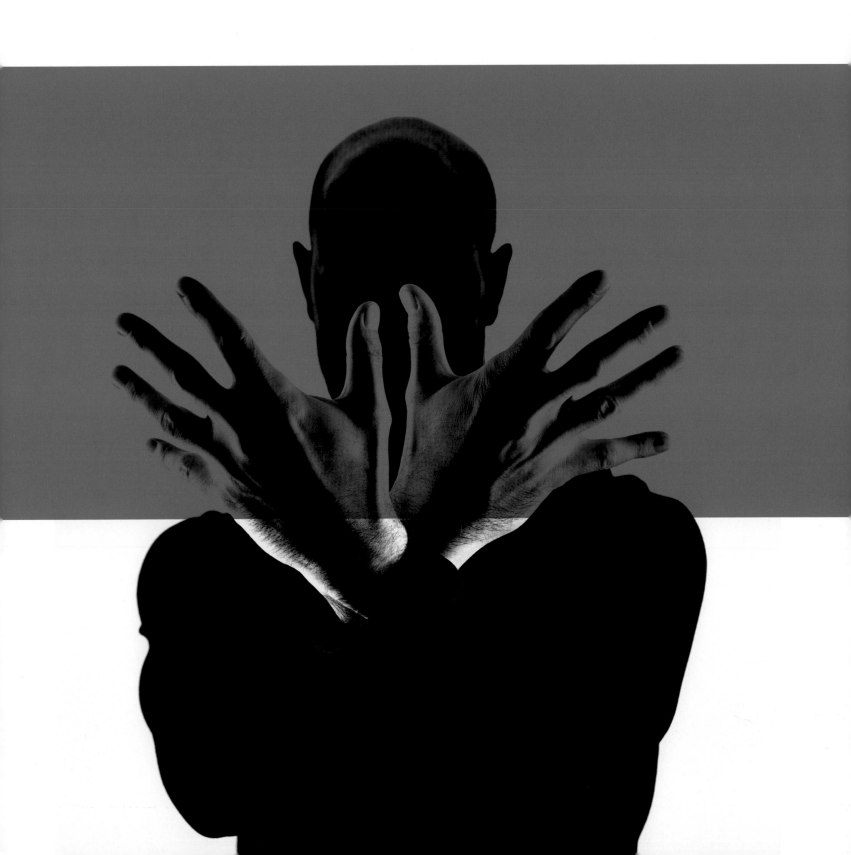

eyes

frontal lobe

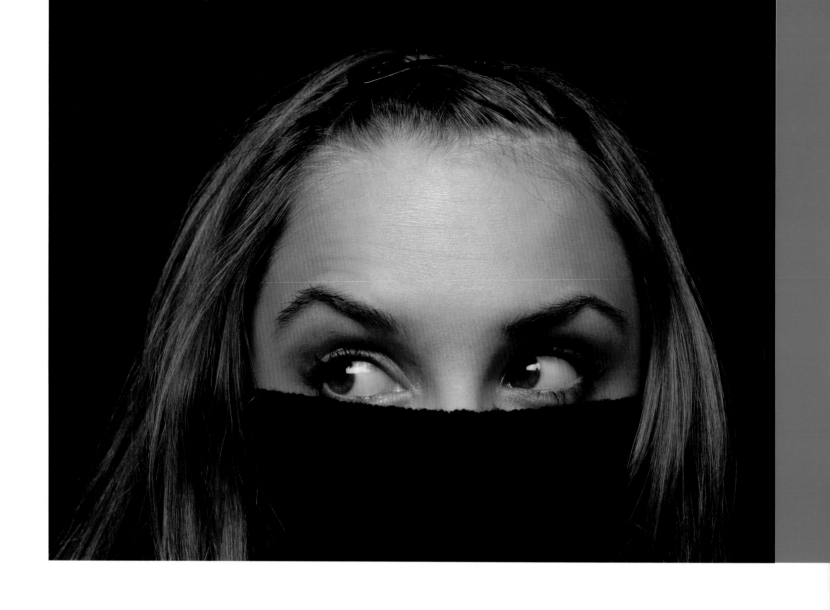

36.
RACHAEL LEIGH COOK
ACTOR

"Seeing is believing."

37.
FREDERICK WELLER
ACTOR

"The frontal lobe is the seat of the imagination."

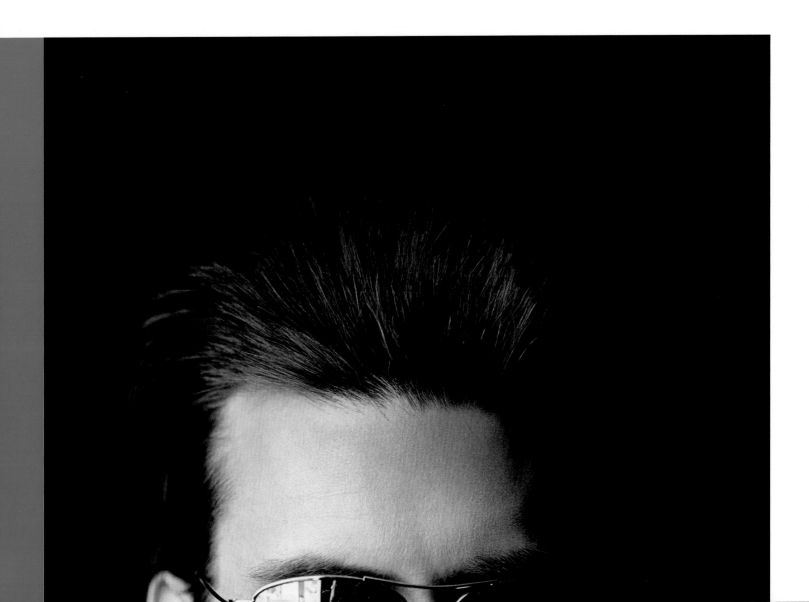

brain

hands

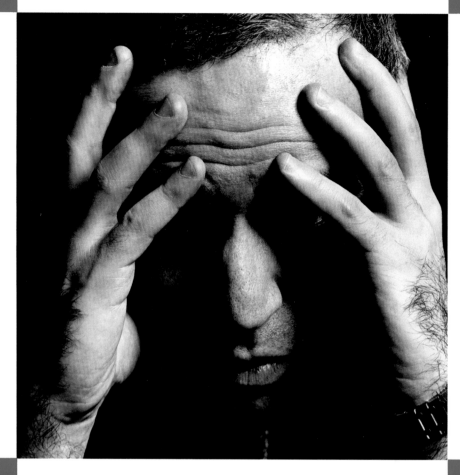

38.

GARRY KASPAROV,
CHESS CHAMPION

"That's what I lived by."

39.

DUSTY BAKER
CHICAGO CUBS COACH

"My hands have been my strength, and my best friends. As a skinny kid with big hands, they were my equalizer in sports and helped me to act and play larger than I was. They gave me strength when there were few muscles elsewhere."

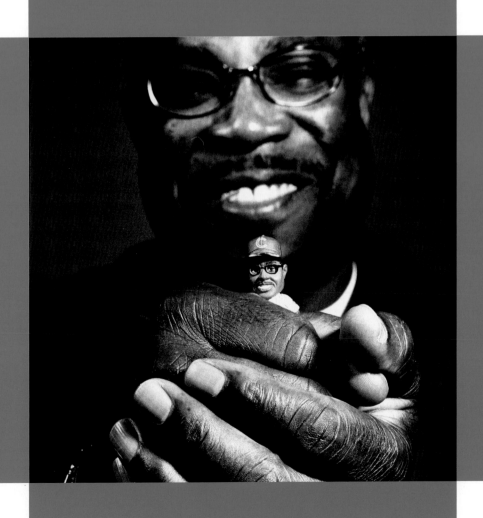

knees

legs

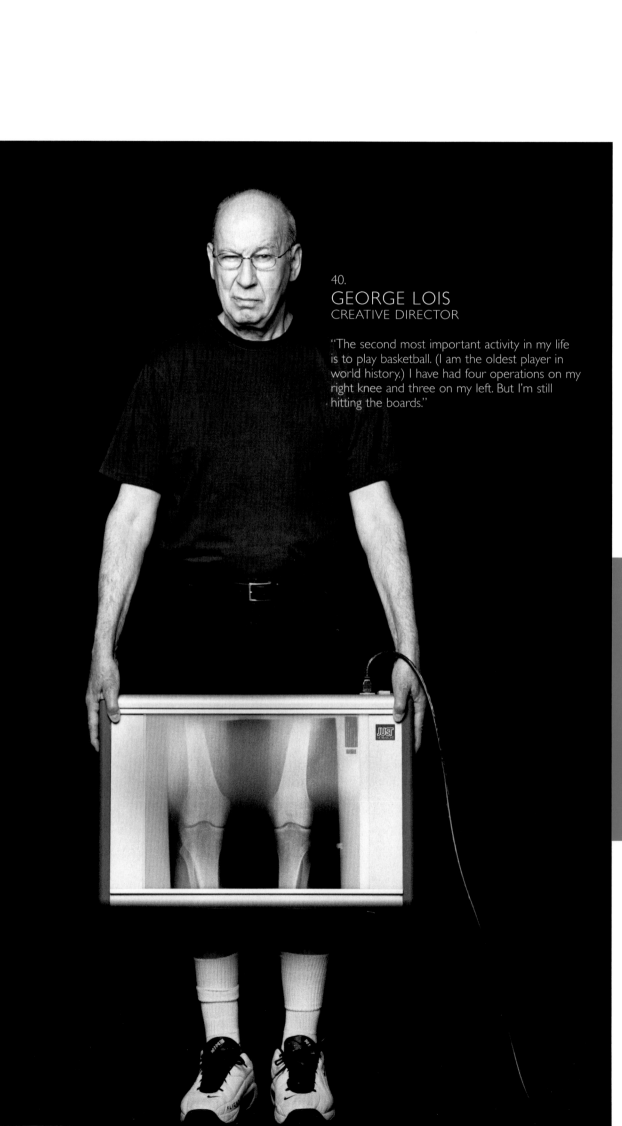

40.
GEORGE LOIS
CREATIVE DIRECTOR

"The second most important activity in my life is to play basketball. (I am the oldest player in world history.) I have had four operations on my right knee and three on my left. But I'm still hitting the boards."

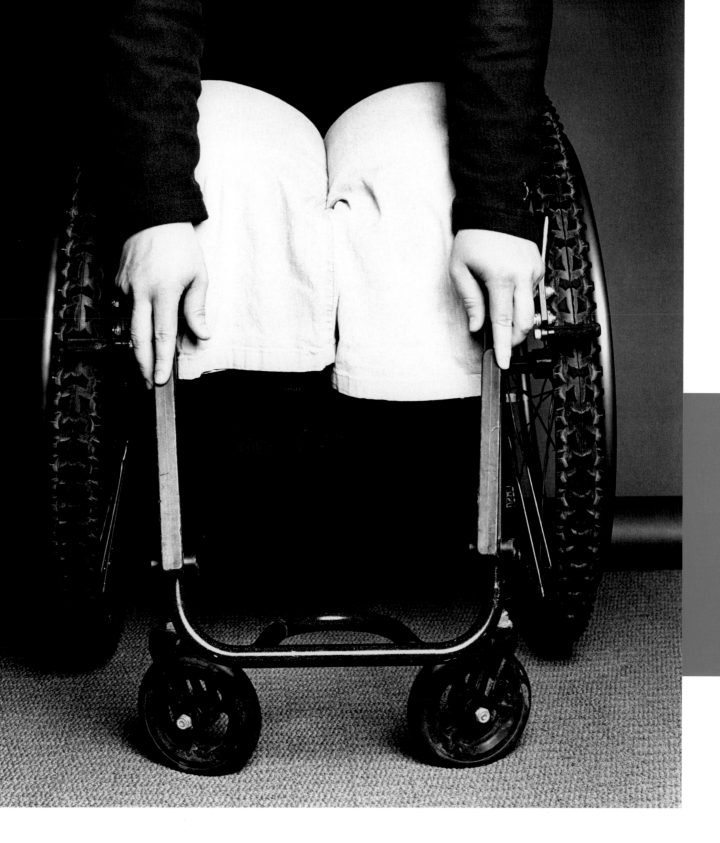

41.
STEPHANI VICTOR
OLYMPIC MEDALIST

"...because they aren't there."

eyes

eyes

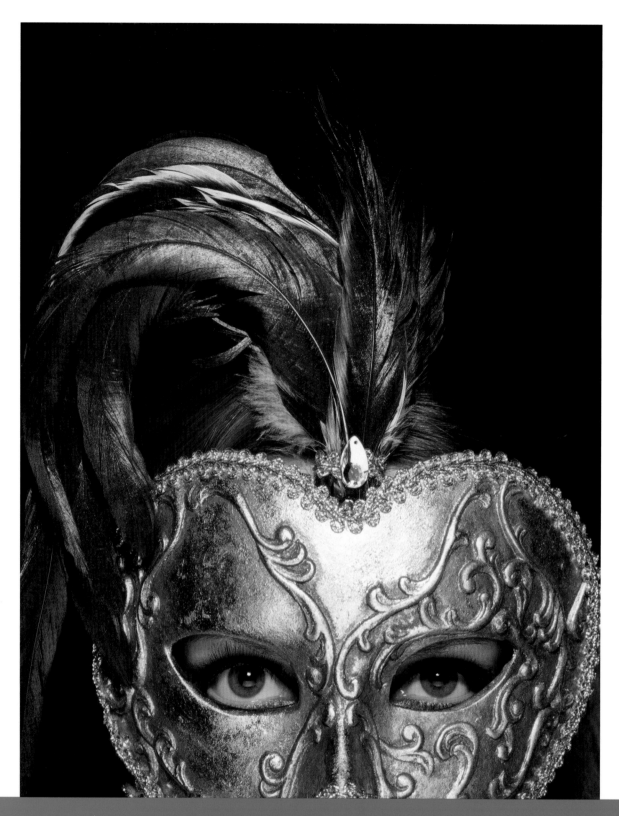

42.
LISA MARIE
PHOTOGRAPHER

"Eyes are kaleidoscopes that reveal the infinite
love and beauty within."

GLORIA ESTEFAN
MUSICIAN

''My eyes are the only place on my body where I can never 'hide.'''

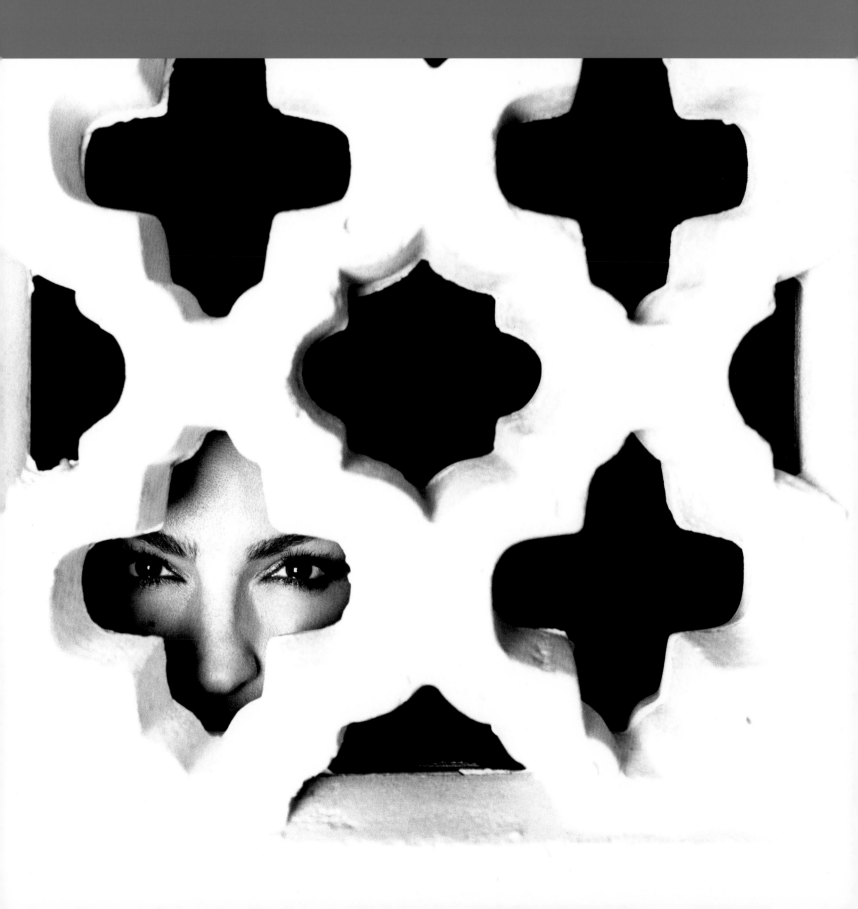

hands

hands

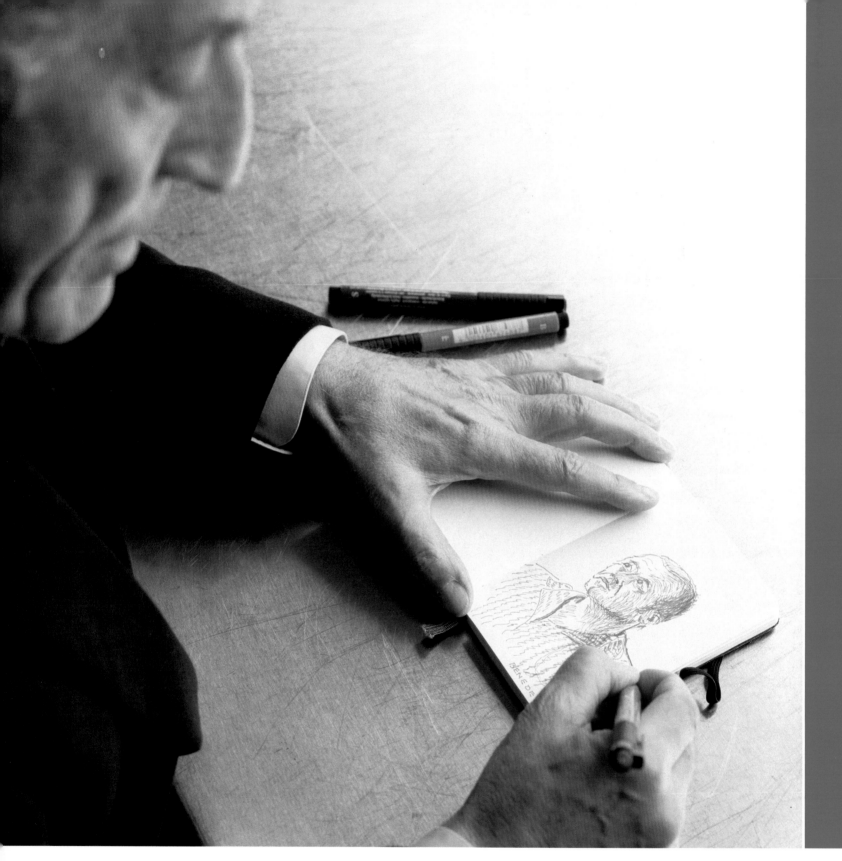

44.
TONY BENNETT
MUSICIAN

"My hands teach me to observe life."

45.

MARIO BATALI
CHEF

"Hands touch, hands feel. Hands pull and push. Hands heal and create and mold and destroy and even drop stuff on the floor."

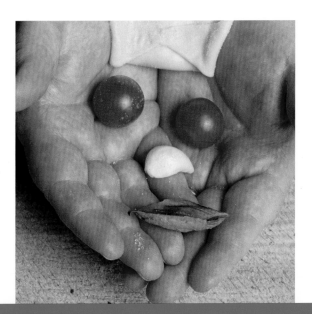

hands

eyes

46.

ROSIE O'DONNELL
COMEDIAN AND ACTIVIST

"My hands, for hugging, holding, and helping."

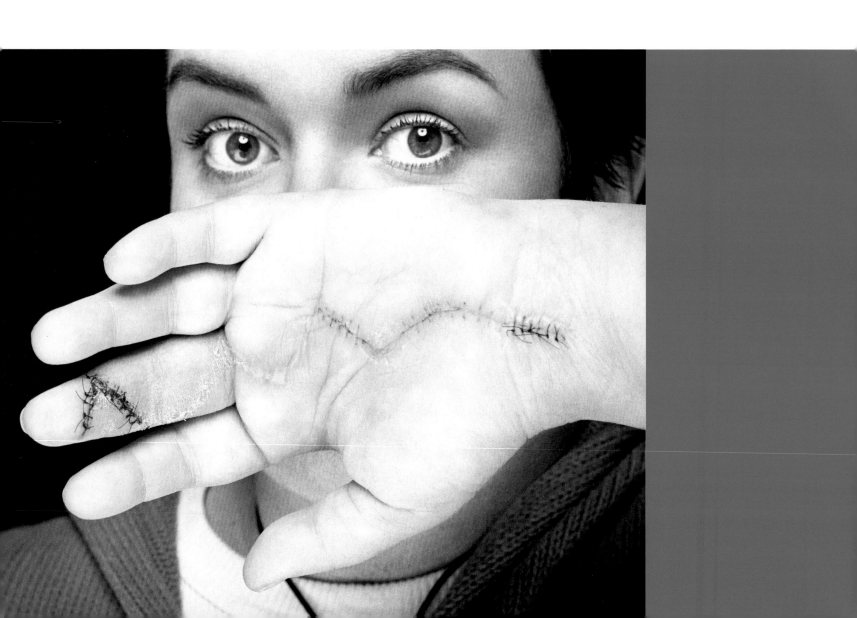

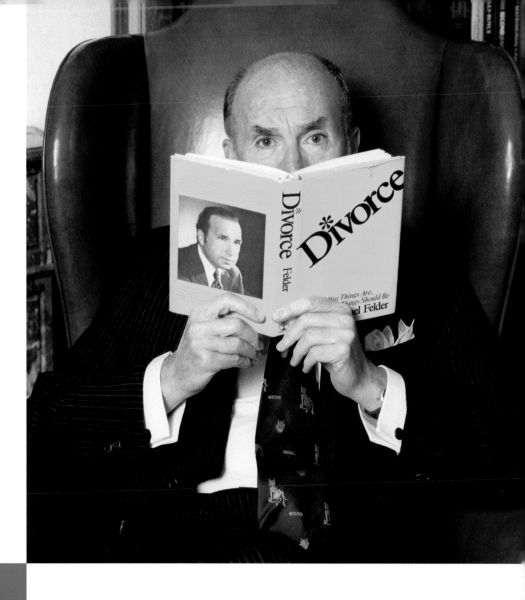

47.

RAOUL FELDER
DIVORCE LAWYER

"The eyes are a person's vacuum cleaner, sucking everything in, not only to the brain but to the soul. Living without vision, having once experienced it, to me is an unimaginable horror. They also reveal, and sometimes, too much so, what is going on behind them."

hands

eyebrows

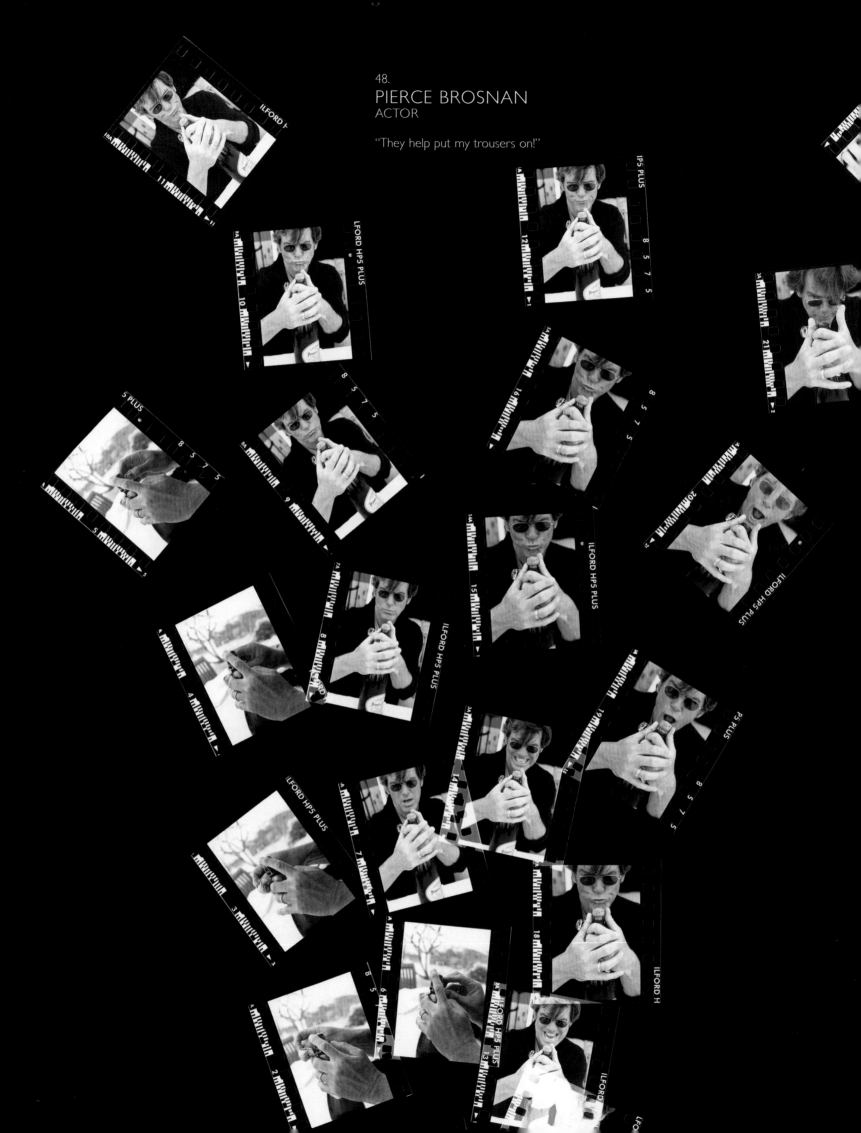

48.
PIERCE BROSNAN
ACTOR

"They help put my trousers on!"

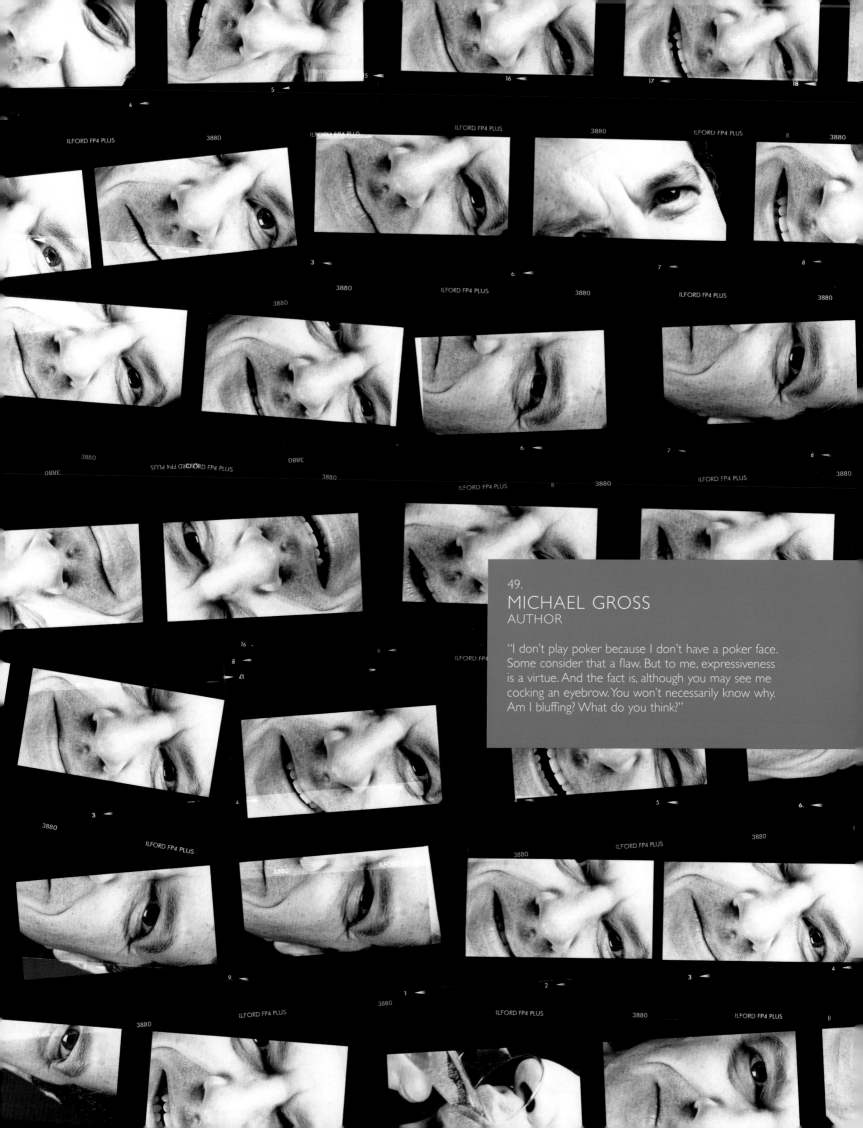

49.
MICHAEL GROSS
AUTHOR

"I don't play poker because I don't have a poker face. Some consider that a flaw. But to me, expressiveness is a virtue. And the fact is, although you may see me cocking an eyebrow. You won't necessarily know why. Am I bluffing? What do you think?"

hair

hair

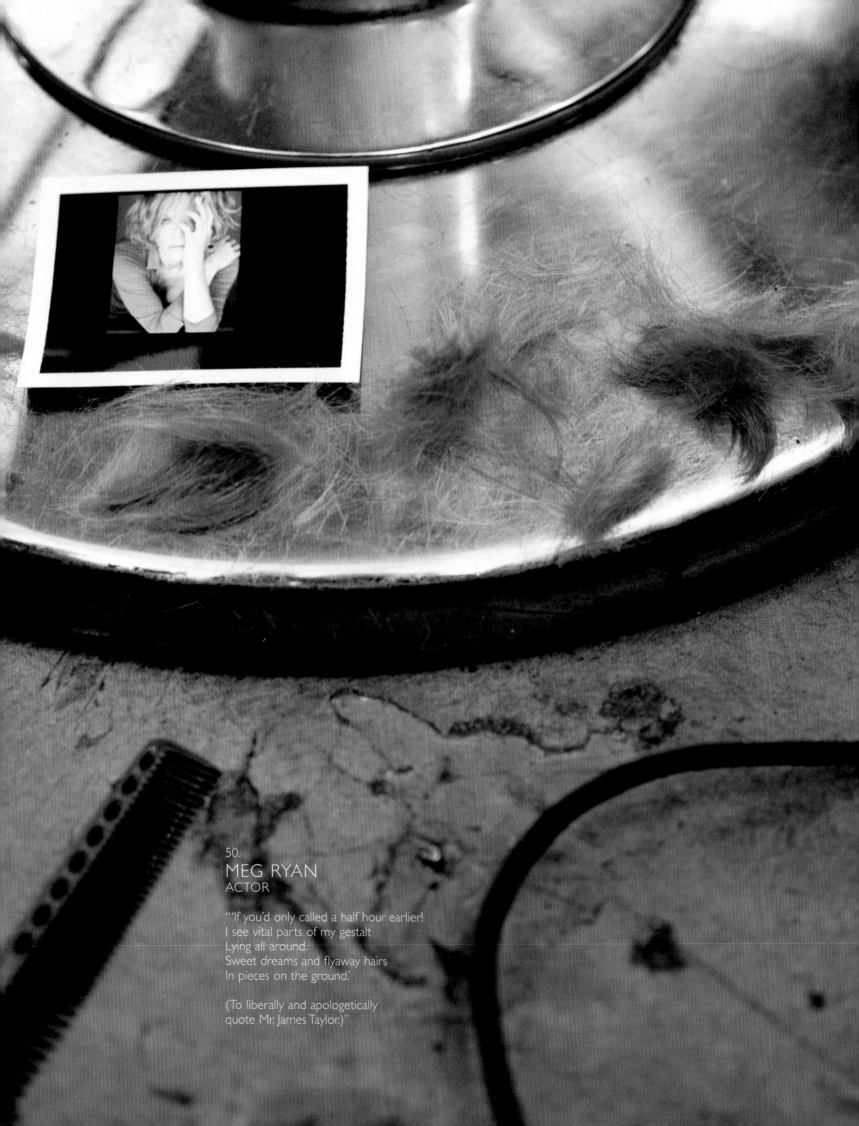

50.
MEG RYAN
ACTOR

"'If you'd only called a half hour earlier!
I see vital parts of my gestalt
Lying all around.
Sweet dreams and flyaway hairs
In pieces on the ground.'

(To liberally and apologetically
quote Mr. James Taylor.)"

51.
ANTONIA BENNETT
MUSICIAN

"I love my hair because it gets me more attention
than anything else on my body. Lord knows, I'd die if
I didn't get enough of it."

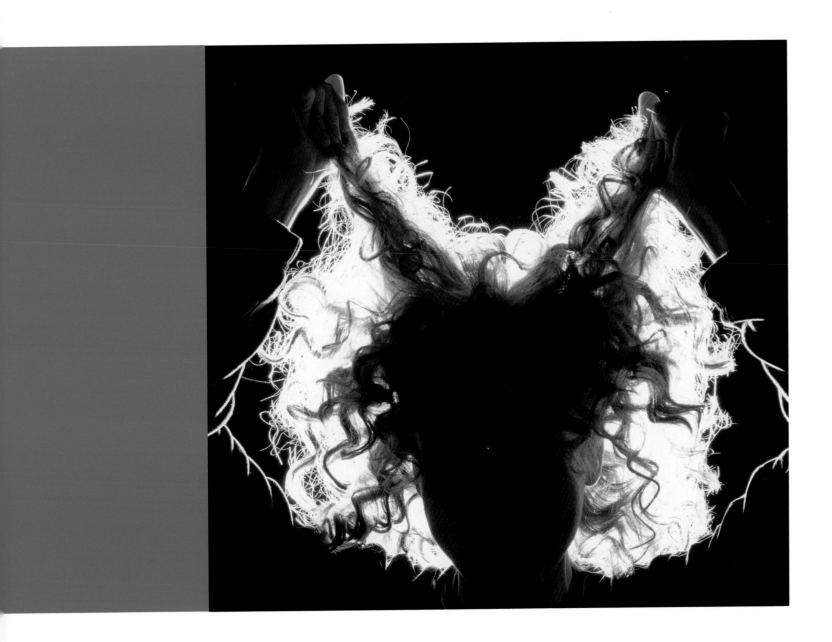

ear

nose

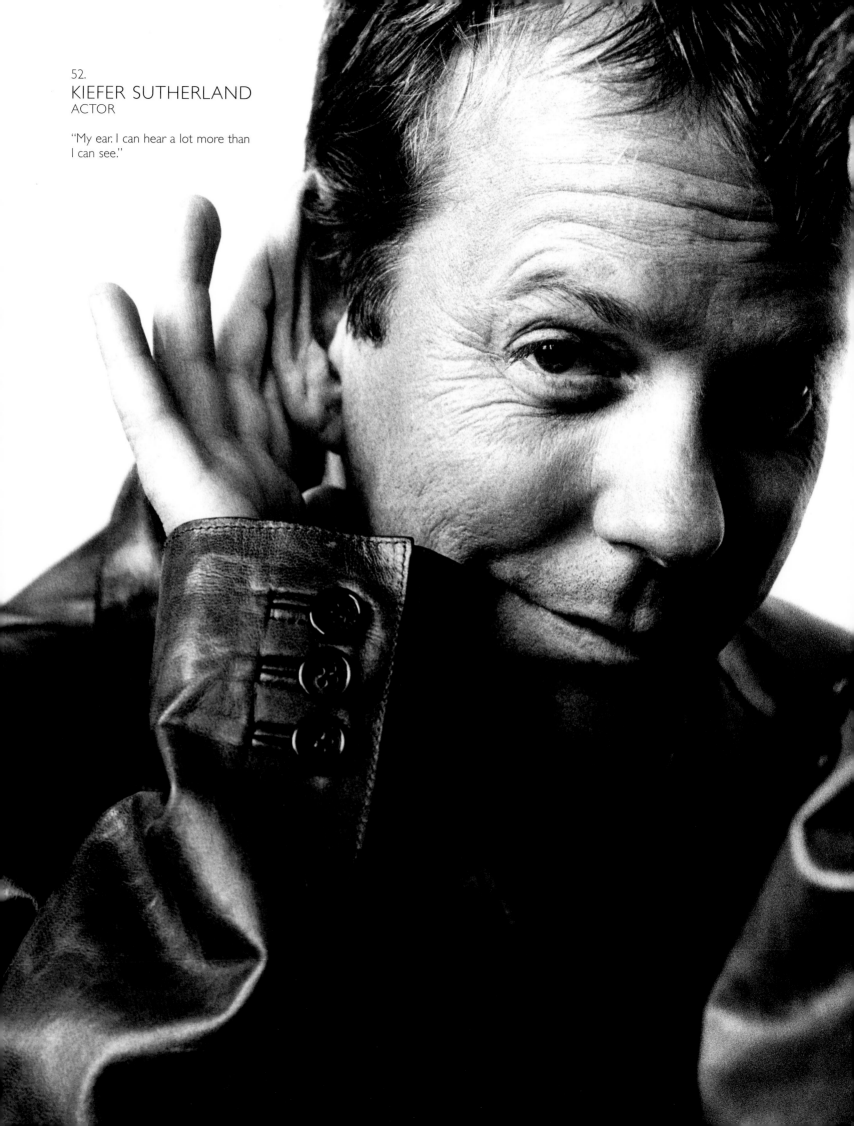

52.
KIEFER SUTHERLAND
ACTOR

"My ear. I can hear a lot more than
I can see."

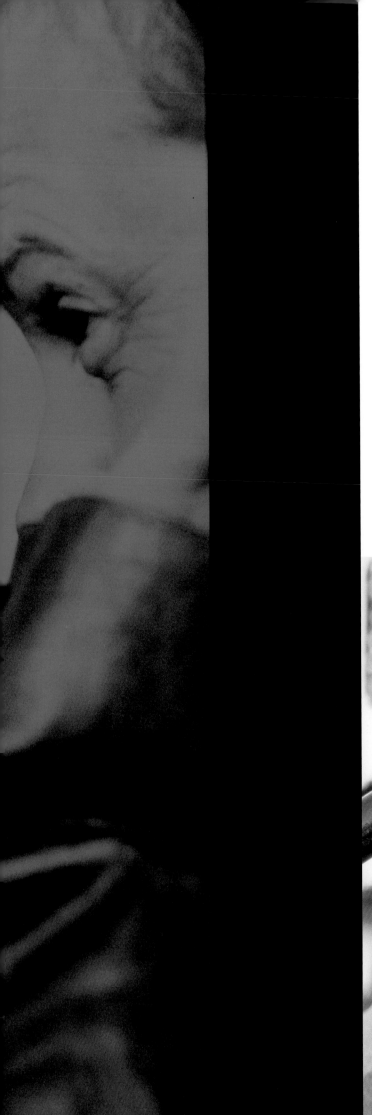

53.

MARK FEUERSTEIN
ACTOR

"When I first got to Hollywood, everyone suggested I get a nose job. I said, "No, like my name, my nose is a part of who I am." Then last year when things got slow, I succumbed to the pressures of the industry and had the enlargement operation."

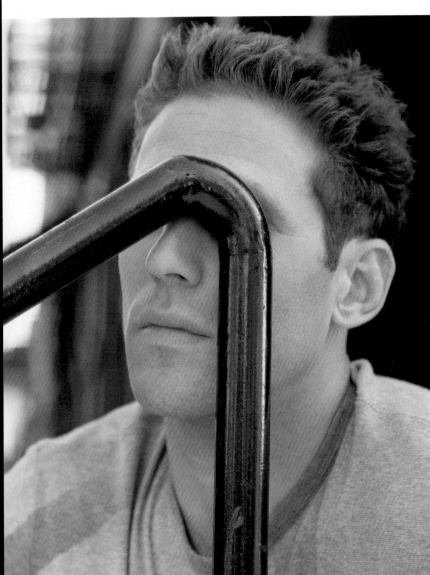

back

stomach

54.
UTE LEMPER
SINGER AND ACTOR

"Back as hell."

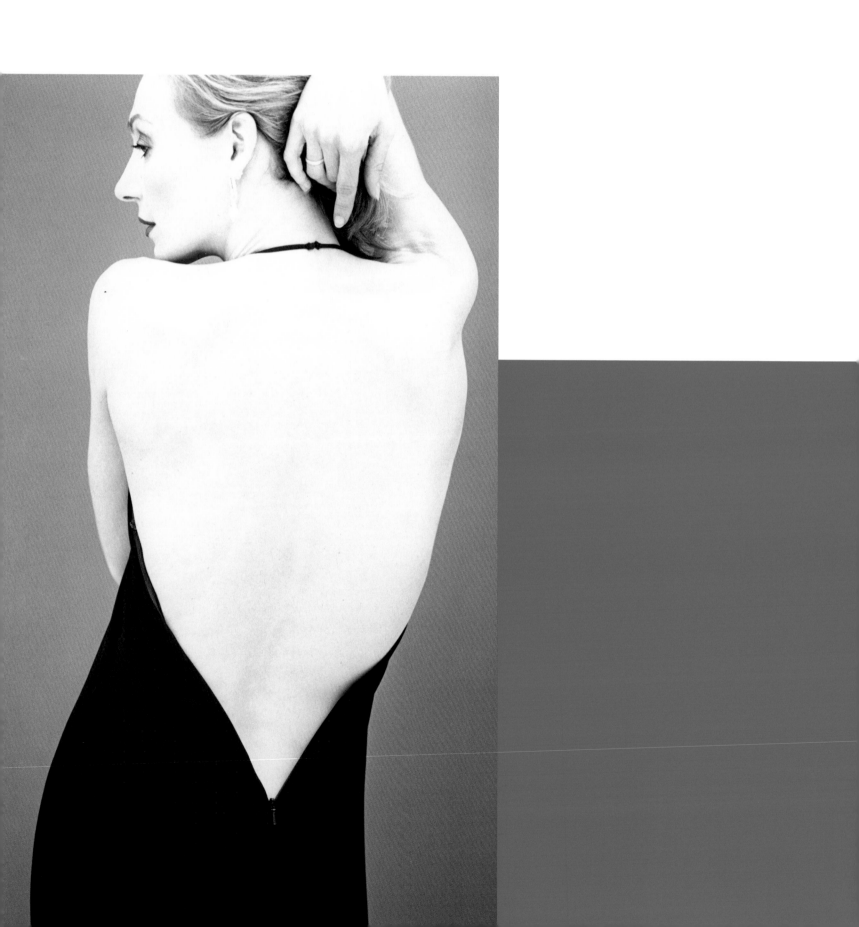

55.
KENNY CHESNEY
MUSICIAN

"In the music business you have to be dedicated and be willing to sacrifice a lot. The same applies in changing your body. There is no substitute for dedication and hard work."

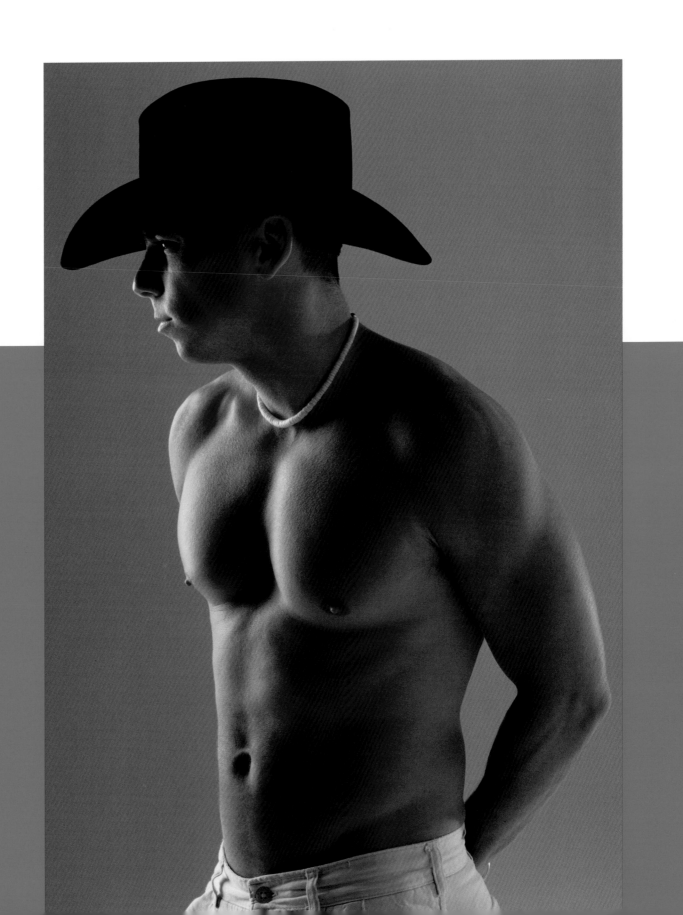

eye

behind

56.
DAVID COPPERFIELD
MAGICIAN

"Don't just see....Dream...."

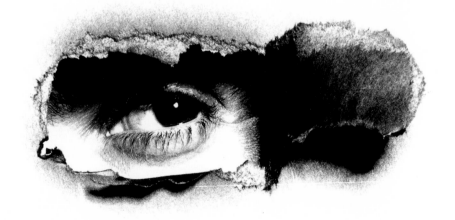

57.
JACKIE MASON
COMEDIAN

"The reason I chose my behind is because I love to sit.
So without it, I'd be in a lot of trouble."

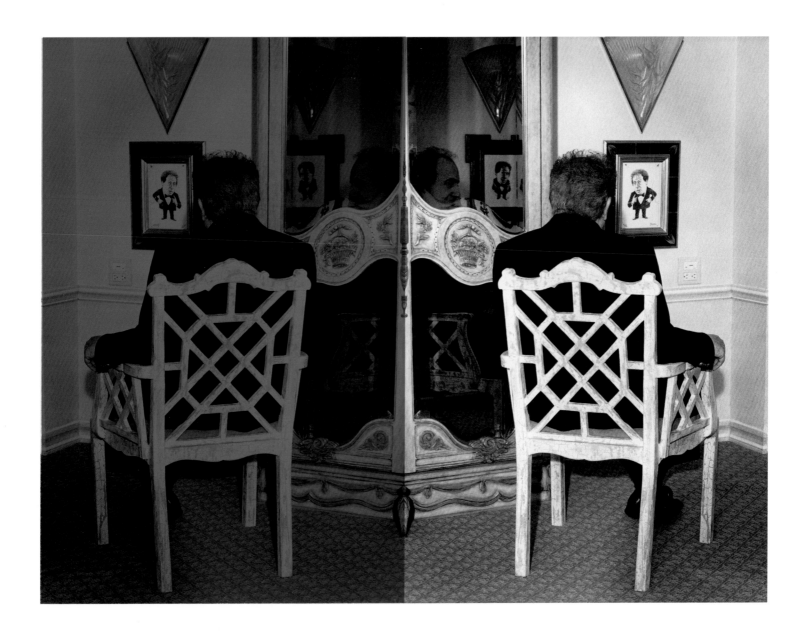

eyes

eyes

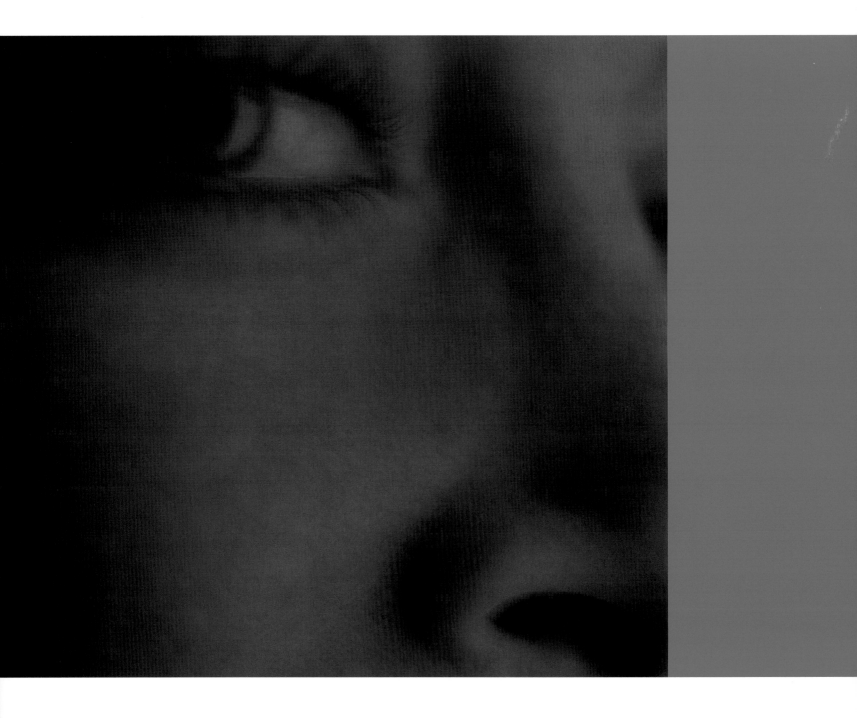

58.
ILLEANA DOUGLAS
ACTOR

"I am, I do, ID."

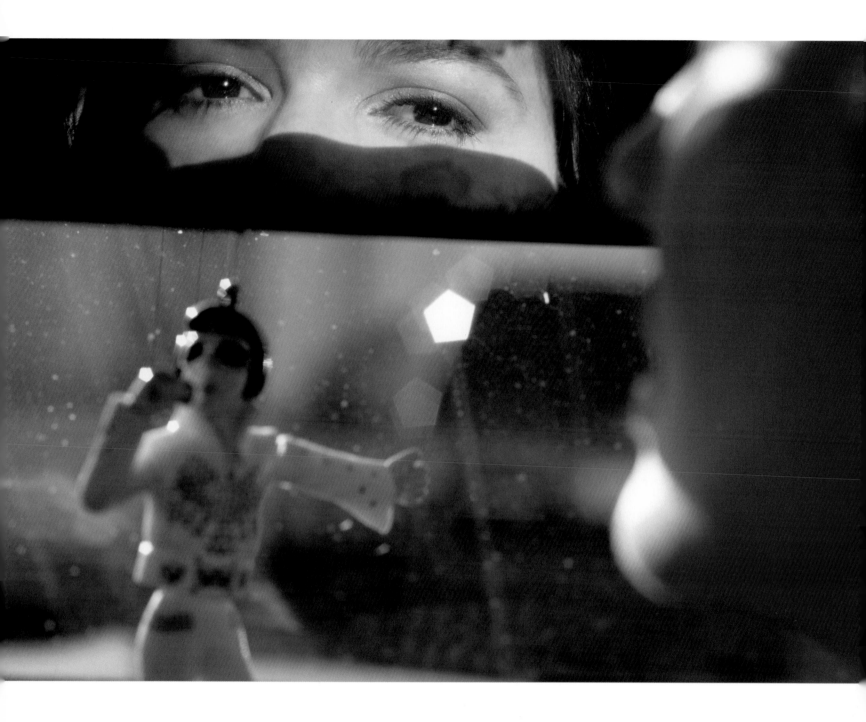

59.
LAURA HARRING
ACTOR

"There is nothing one can hide with the eyes; every thought, every glance, every feeling, shown nakedly for the whole world to see."

eyes

chest

60.

MONICA LEWINSKY
DESIGNER

"The eyes have it...for with them, I can let you in
or shut you out."

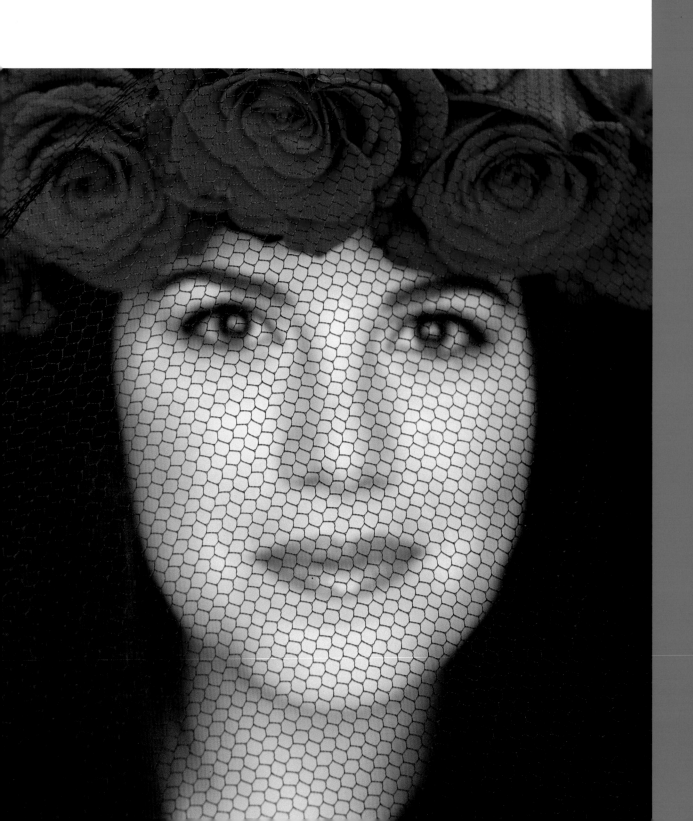

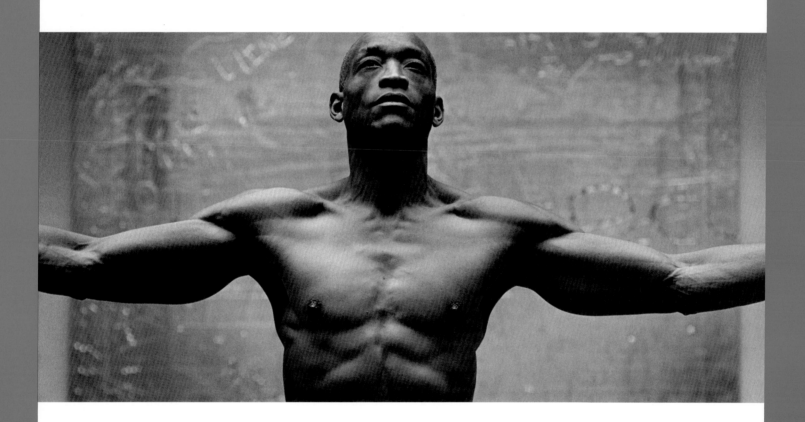

61.

BILL T. JONES
CHOREOGRAPHER

"My chest represents my physical self-confidence
and it is where my heart lies."

tattoo

stomach

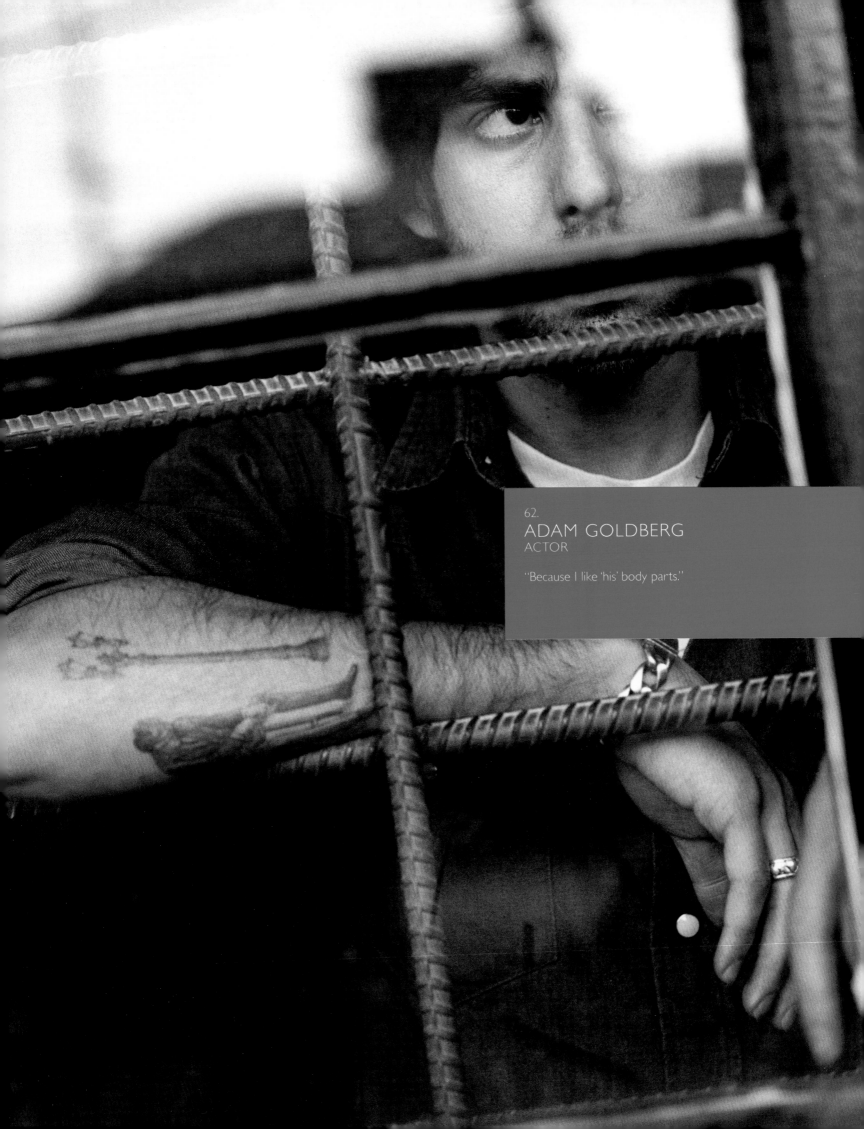

62.
ADAM GOLDBERG
ACTOR

"Because I like 'his' body parts."

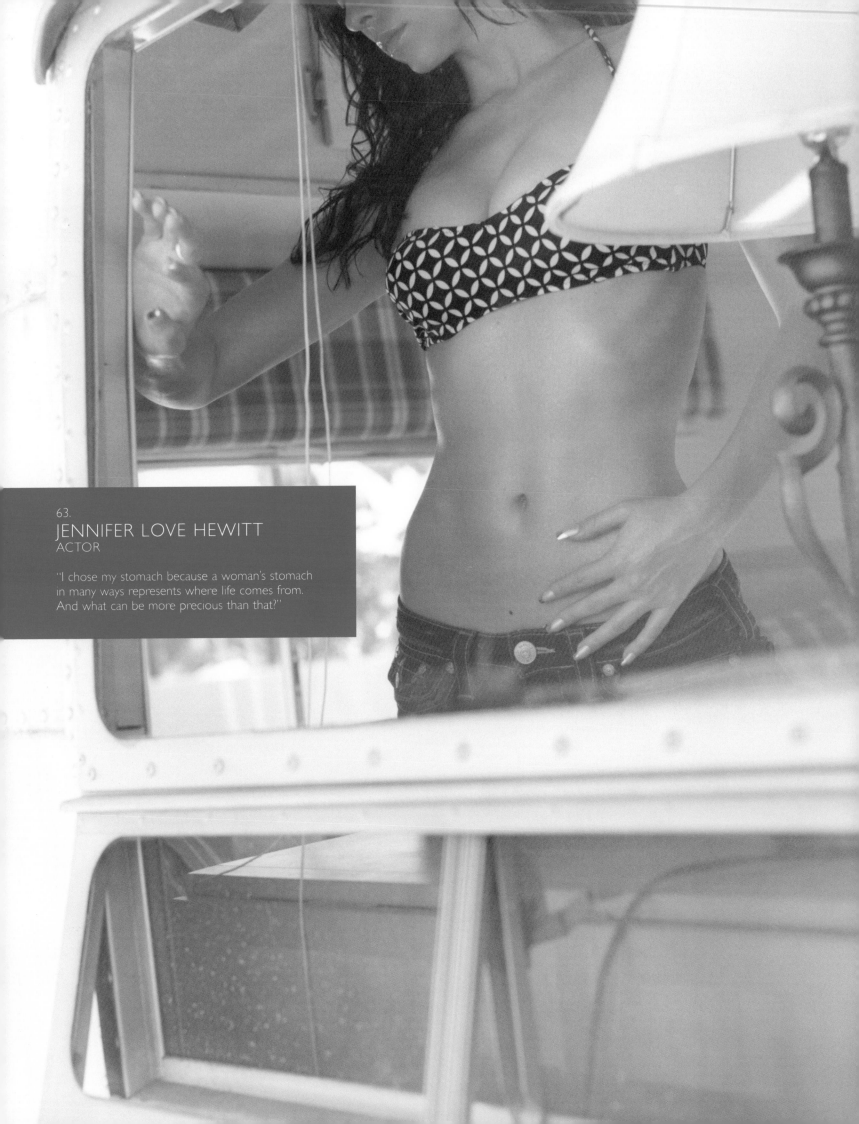

63.
JENNIFER LOVE HEWITT
ACTOR

"I chose my stomach because a woman's stomach in many ways represents where life comes from. And what can be more precious than that?"

spirit

chin

64.
SUSAN SARANDON
ACTOR

"My spirit because, in the end, that's really
what I am."

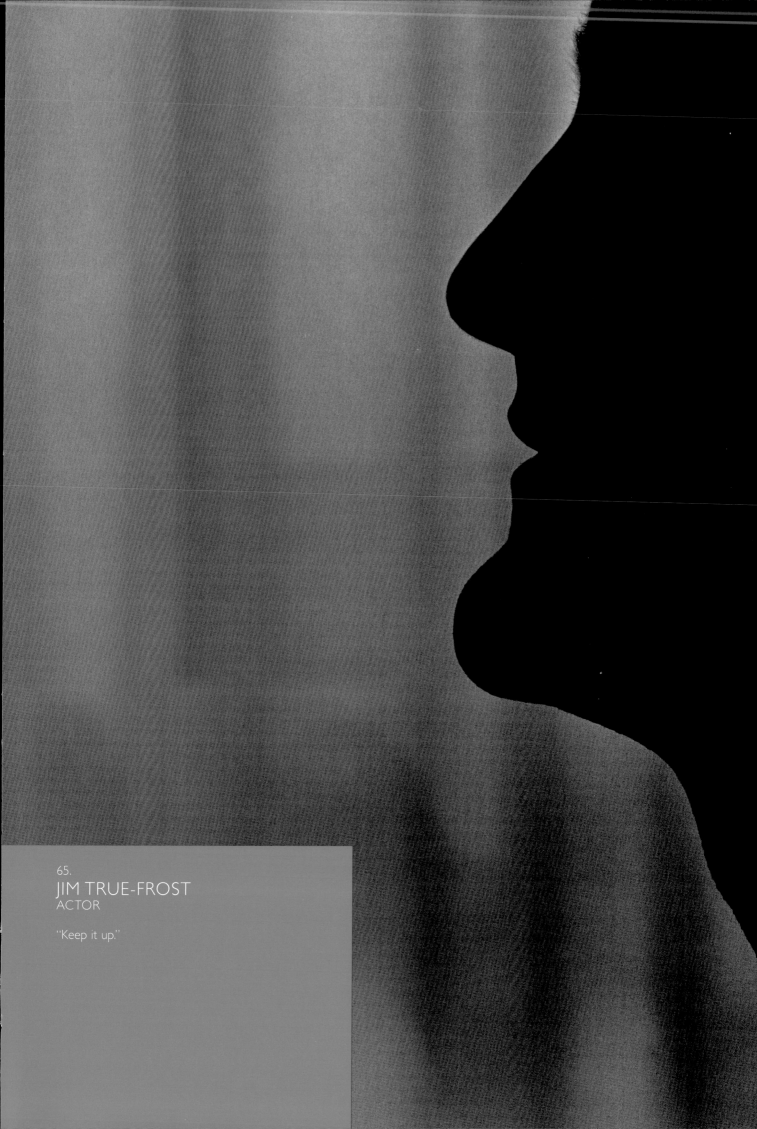

65.
JIM TRUE-FROST
ACTOR

"Keep it up."

eyes

profile

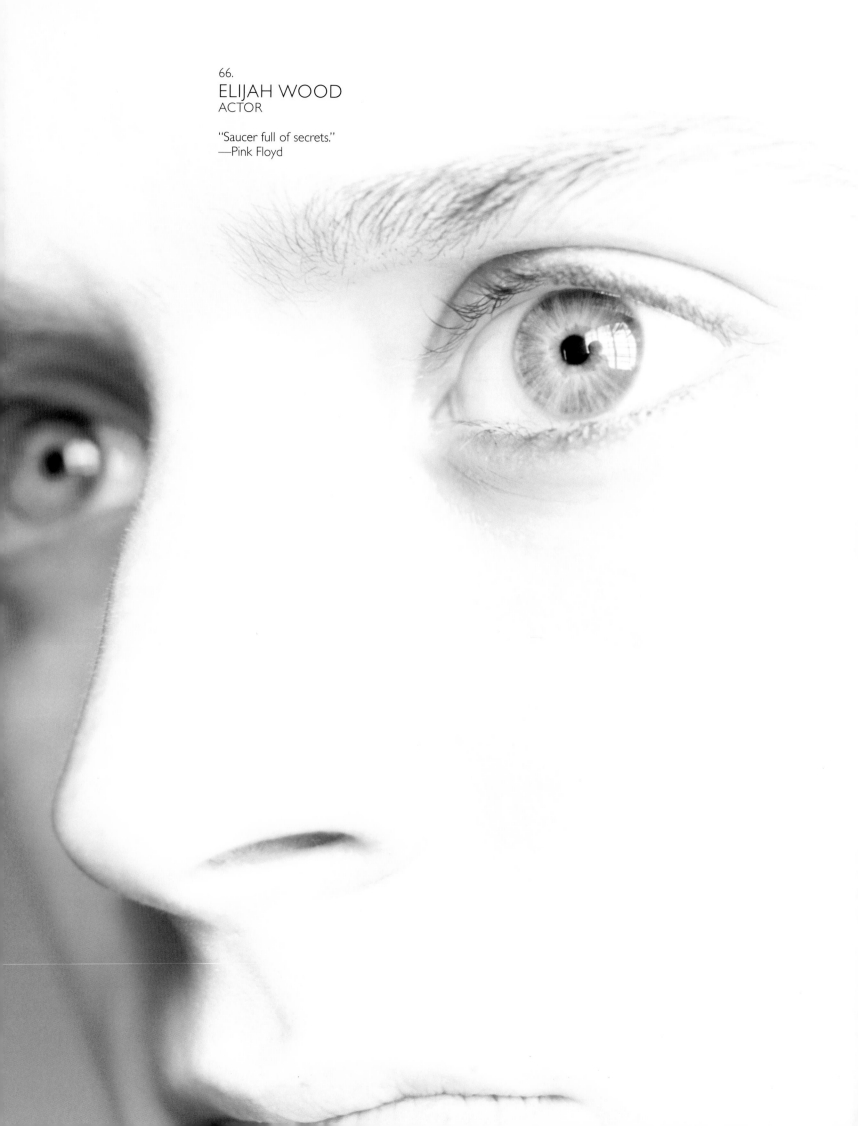

66.
ELIJAH WOOD
ACTOR

"Saucer full of secrets."
—Pink Floyd

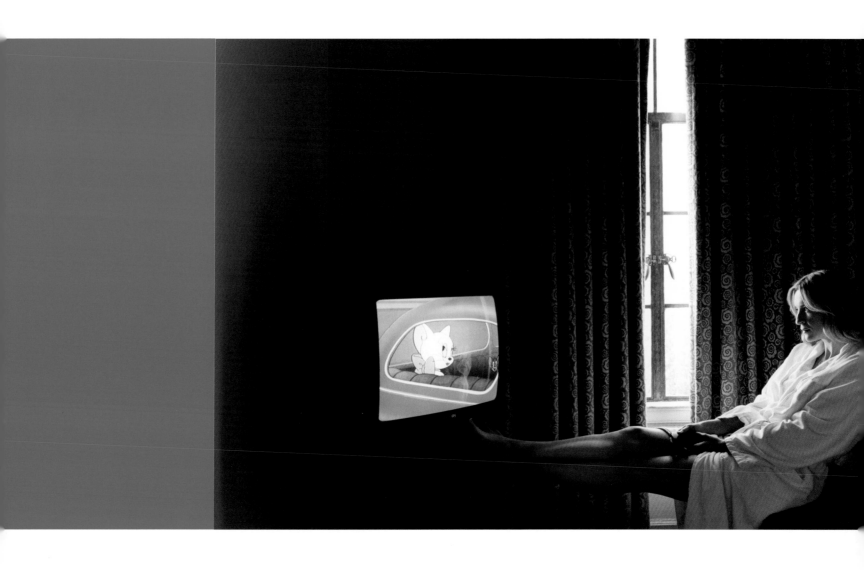

67.
EVER CARRADINE
ACTOR

"I chose my profile because it reminds me of my family. Whenever I see a photo of myself taken from the side, I see my dad, my uncles, and my grandfather. My profile is, undeniably, a Carradine profile."

eyelids

lips

68.
JACK PARRY
SCHOOLCHILD

"Without them I couldn't go to sleep and I would have to lick my eyes rather than blink."

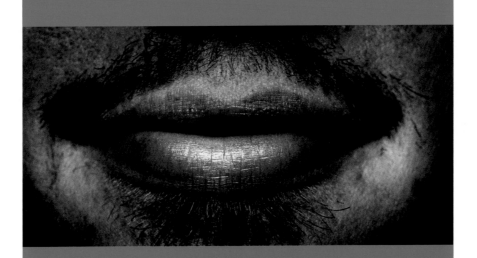

69.
LUKAS HAAS
ACTOR

"I get to sing with them and I get to kiss with them."

nape of neck

back of neck

70.

GAEL GARCÍA BERNAL
ACTOR

"I believe my nape is the most precious part of my
body because I never see it. I'm not self-concious of it
therefore it has its own personality. I will never be
able to identify it from anyone else's nor will I be able
to see it the way anyone else can see it."

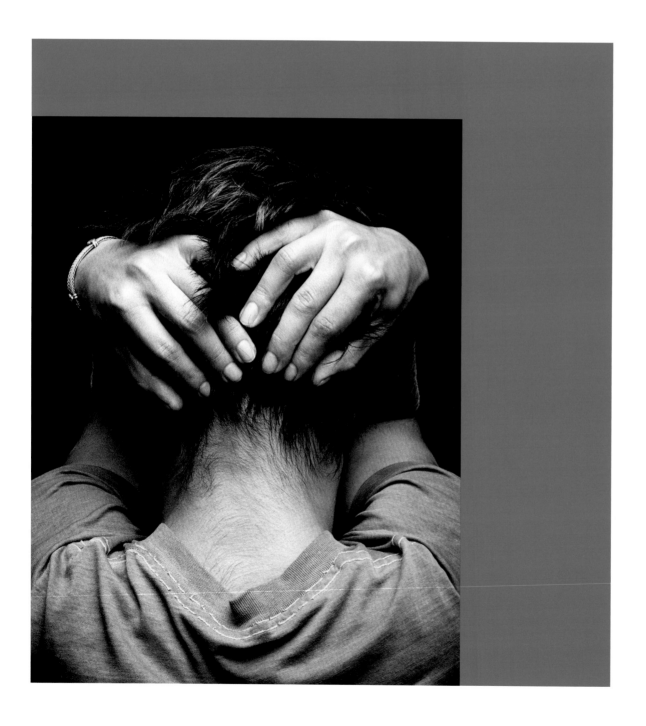

71.
NATHANIEL PARKER
ACTOR

"My wife had no hesitation about this.
That makes me tingle."

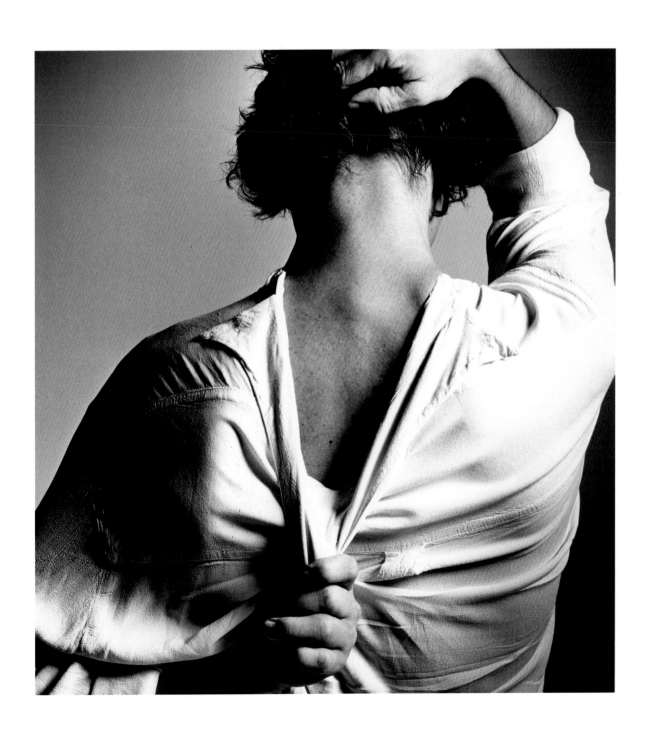

small of back & butt

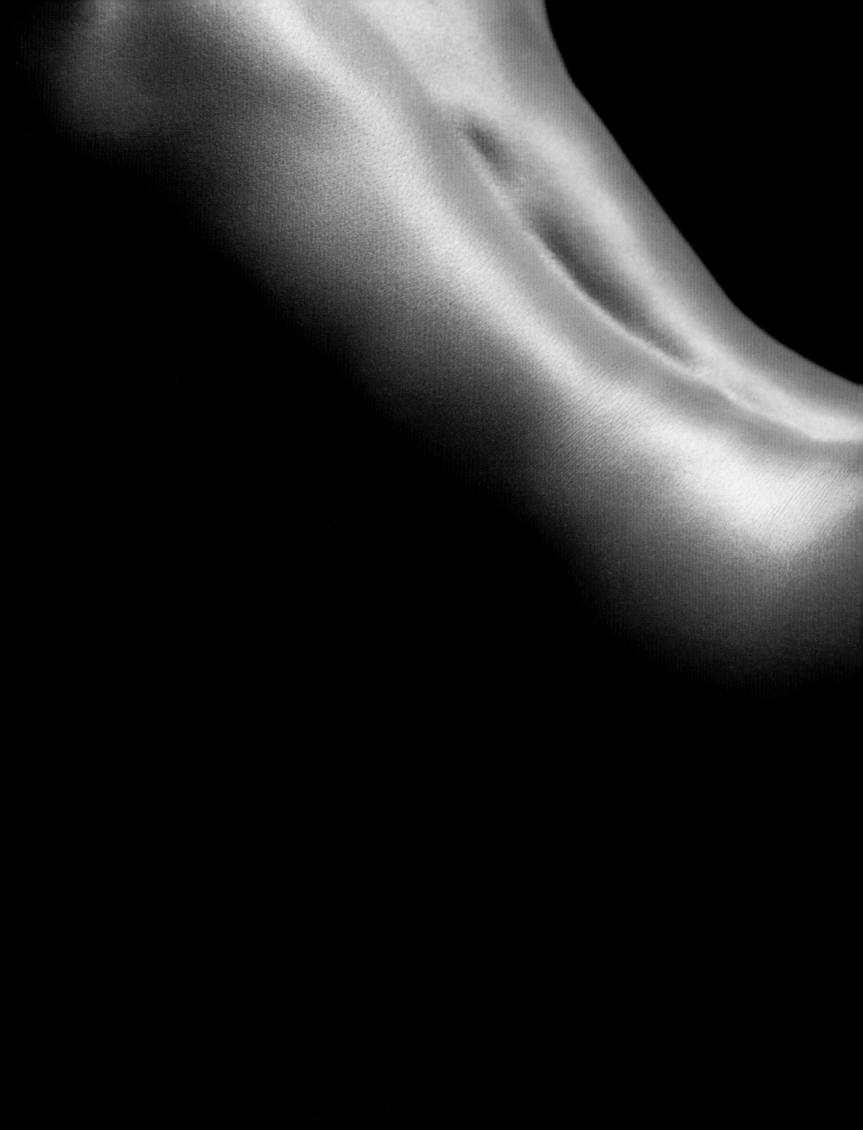

BROOKE BURKE
MODEL

"My favorite place to be kissed is the small of my back; my ass? Why not!"

eyes

eyebrows

73.
ANH DUONG
ARTIST

"As I had to pose with my right hand to paint it,
I had to let my inexperienced left hand accomplish
the task. As I was going through the motion, to my
surprise, that virgin hand showed me no fear or
stumbleness, delivering brush strokes, with the luck
of the first time, fresh and innocent, yet secure and
bold. At that moment I understood it was my eyes
that were painting, not my hand, it was that vision
that created, it was what I saw that made it happen,
and the hand there to serve it."

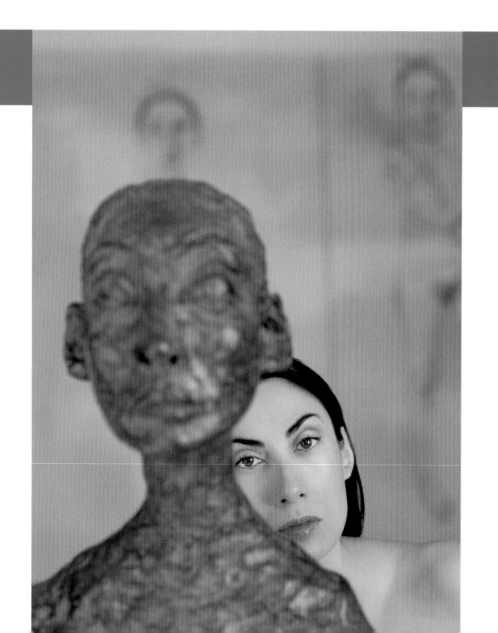

74.

TOMMY HILFIGER
DESIGNER

"My eyebrows are precious. I look at them everyday and wonder why they are so thick and then I think that they are doing a good job protecting my passengers."

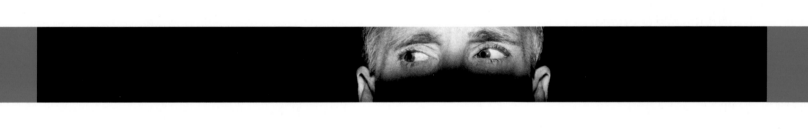

ear

nose

75.

GEORGE S. MILLS
JOURNALIST

"You ask what part of me I would single out as precious, I have to mention my eyes, brain, heart, hands. But since the onset of old age, I have been greatly bothered by my inability to hear exactly what is said, even with hearing aids. In a discussion of four or five people, I'm soon left far behind. Or all too often, a phone conversation is a disaster. In a word, good ears would be precious to me if I had them. Or one would be if that was all that were available."

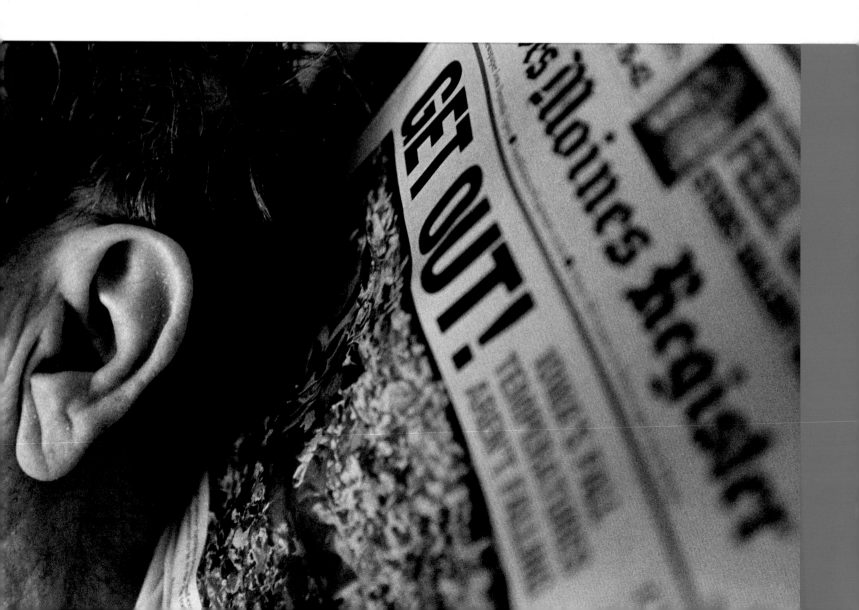

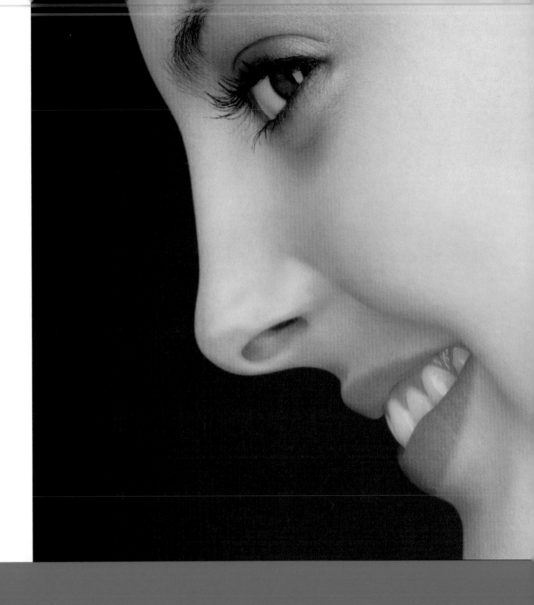

76.
EVA AMURRI
ACTOR

"I like it because it's such a mix of both of
my parents that when I look at it, I know where
I come from."

eyes

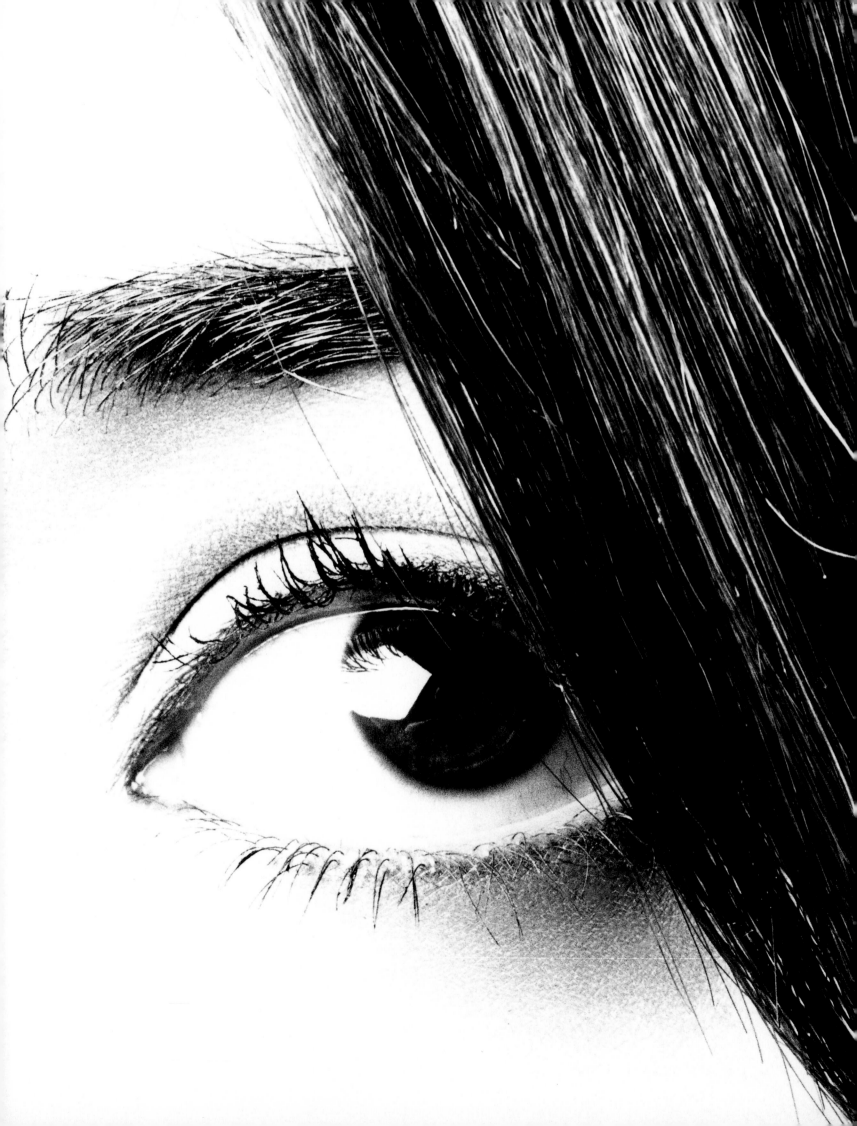

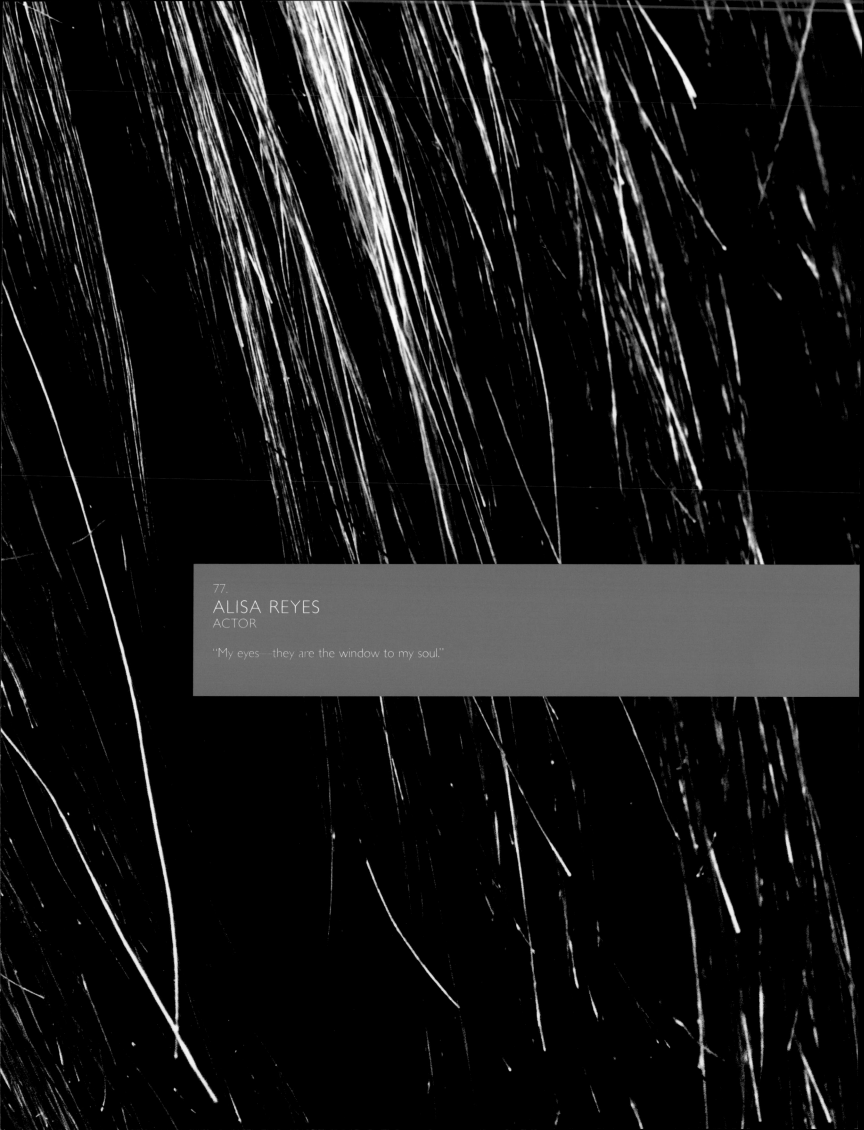

77.
ALISA REYES
ACTOR

"My eyes—they are the window to my soul."

eyes

mouth

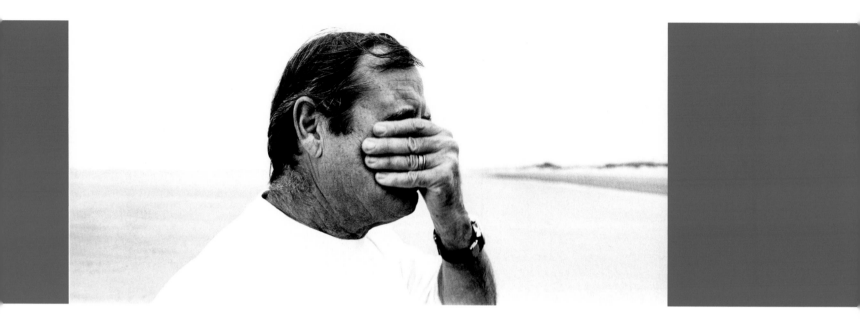

78.
PAUL THEROUX
AUTHOR

"My greatest pleasures include looking upon the
strangeness and beauty of the world, writing in
longhand, and reading. I would be desolated without
my eyesight. I know this. Forty years of traveling in
sunny places caused solar damage to my eyes,
requiring double cataract surgery. I was briefly blind—
and horrified. My passion as a writer was expressed
by Joseph Conrad in his mission statement:
'Above all, to make you see.'"

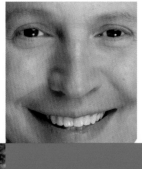

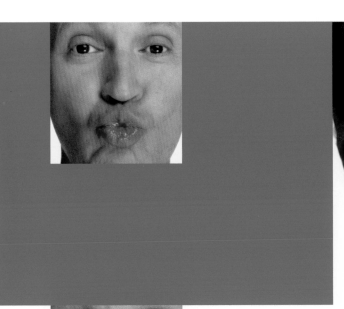

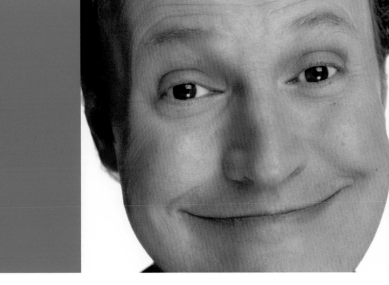
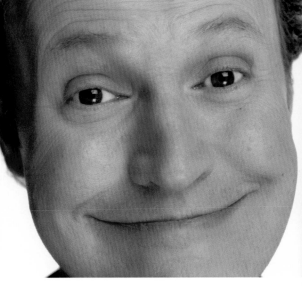

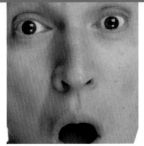

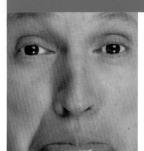

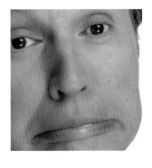

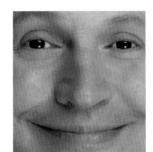

79.
BILLY CRYSTAL
ACTOR

"The mouth that launched a thousand quips."

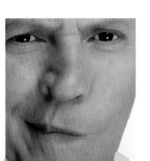

pregnant wife / family

breasts

80.
ANTHONY LAPAGLIA
ACTOR

"Needs no explanation."

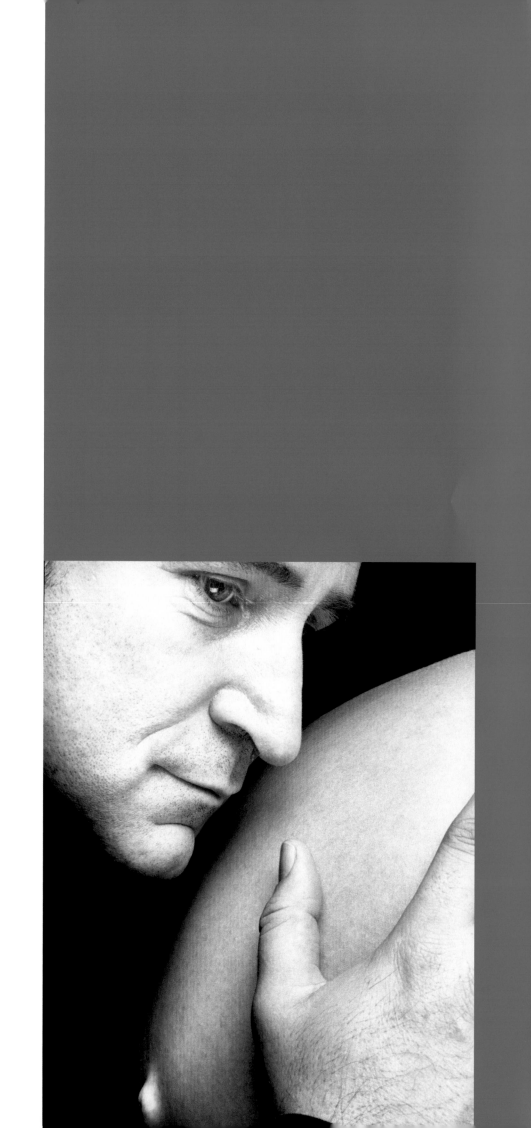

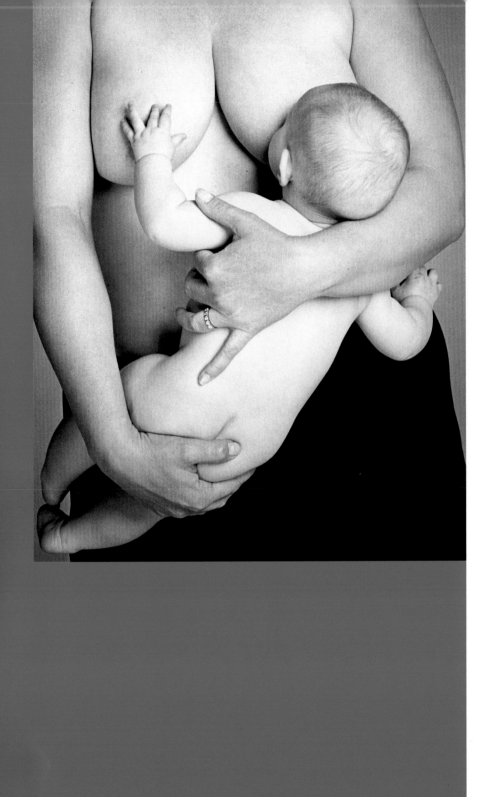

81.
EMME
MODEL

"Knowing that I can nourish my daughter
is nourishment for my soul."

face

smile

82.
DUSTIN HOFFMAN
ACTOR

"Face it. It's all I got."

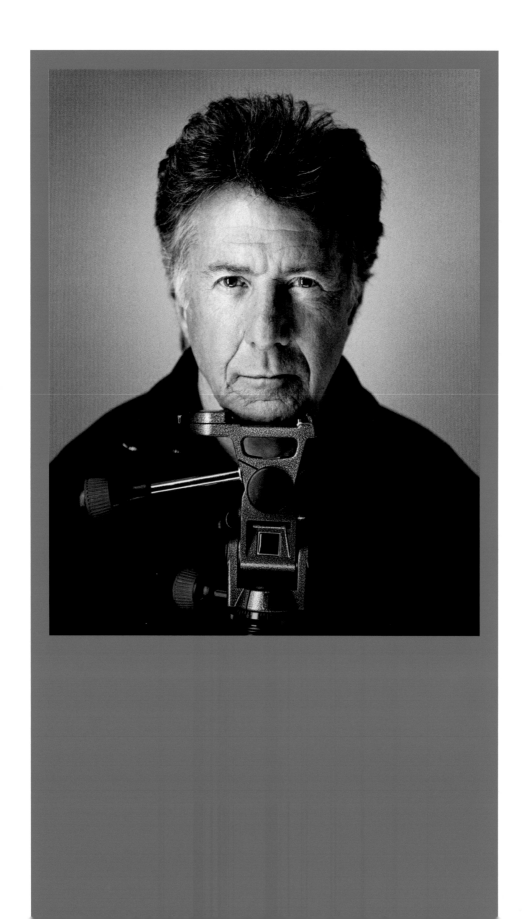

83.
ERICA JONG
AUTHOR

"Without my smile, I'd never have survived."

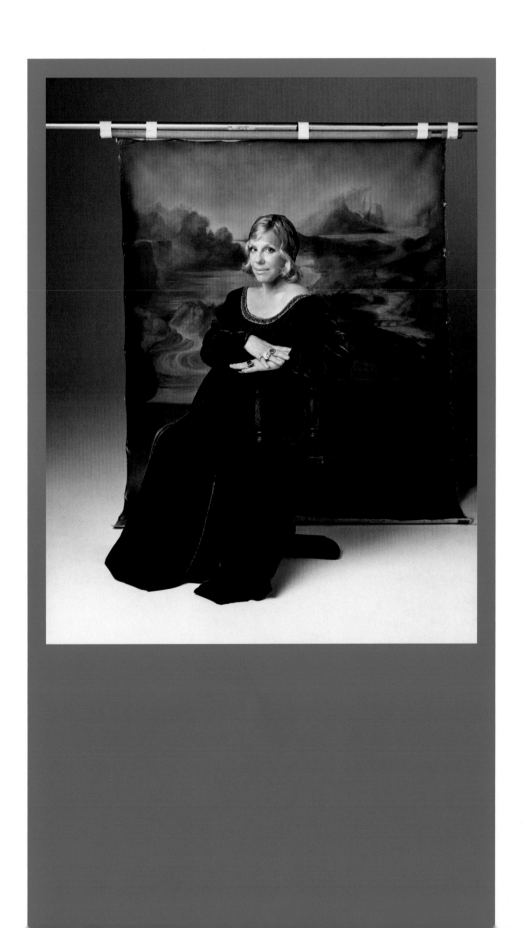

back

back

84.
CHLOË SEVIGNY
ACTOR

"My back is precious to me because it is crooked,
but it still holds me up."

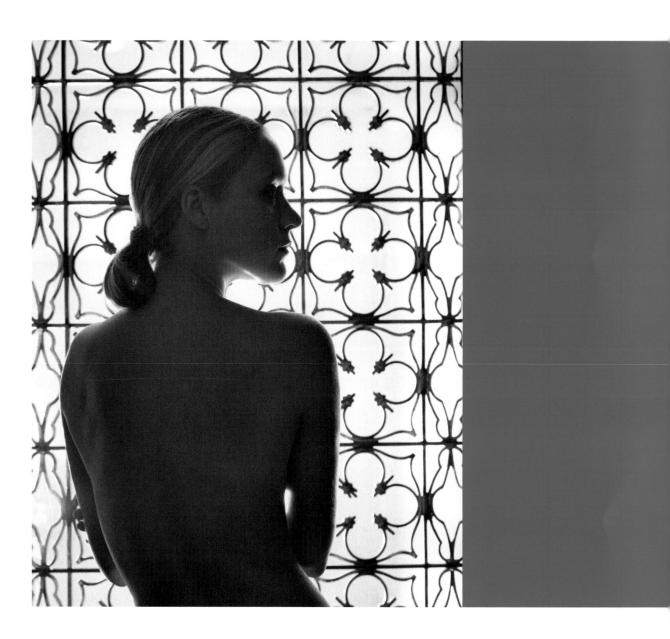

85.

JULIETTE LEWIS
ACTOR

"I always felt my back represents female beauty.
It's strong and graceful."

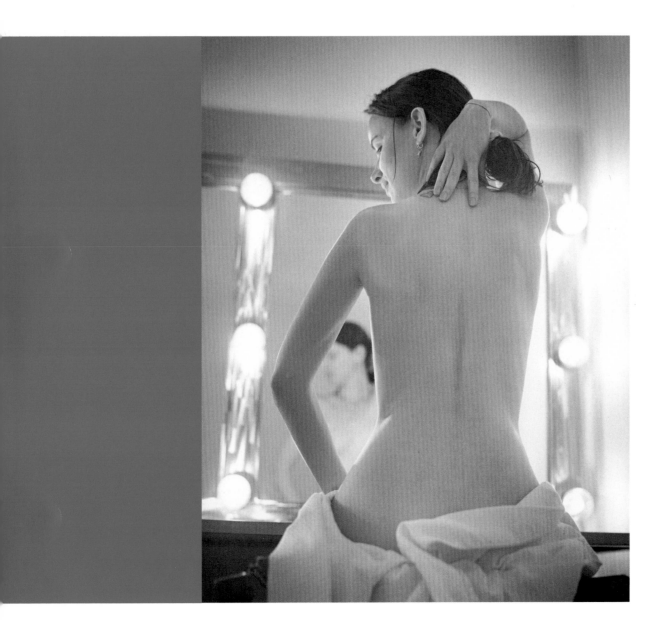

scar

stomach

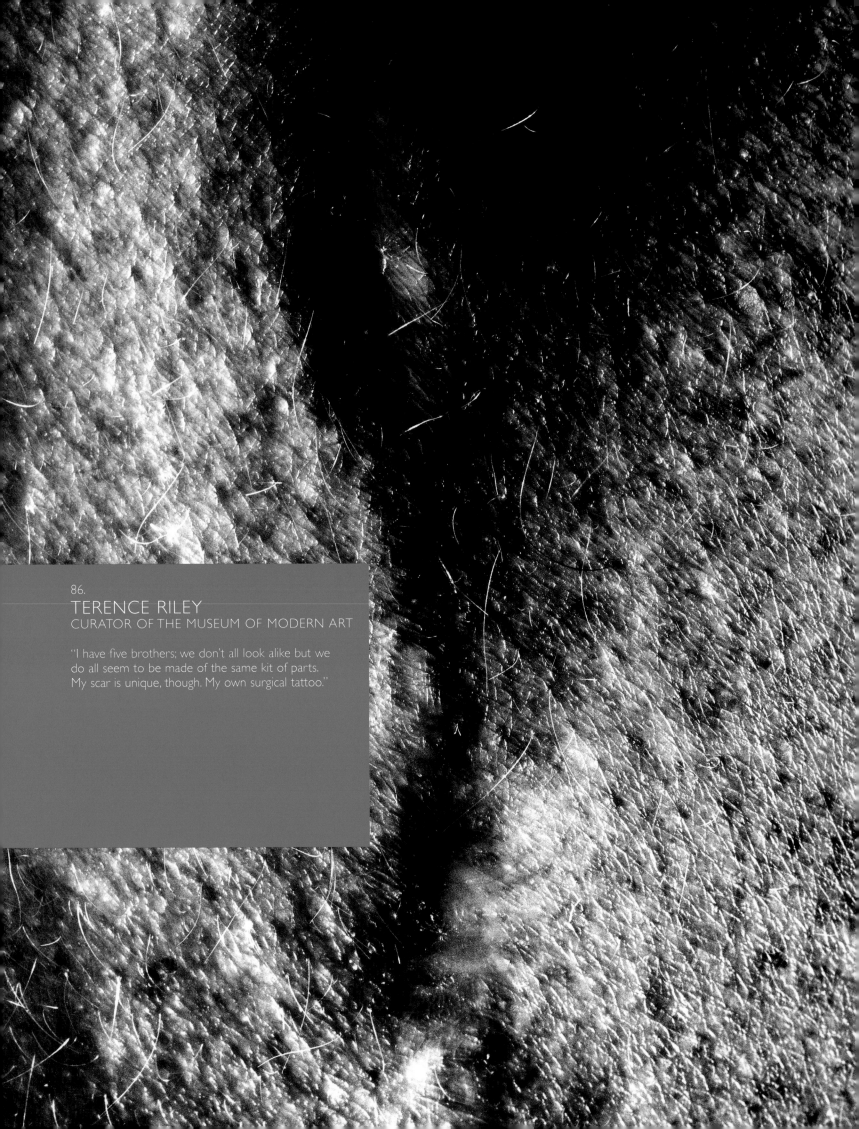

86.
TERENCE RILEY
CURATOR OF THE MUSEUM OF MODERN ART

"I have five brothers; we don't all look alike but we
do all seem to be made of the same kit of parts.
My scar is unique, though. My own surgical tattoo."

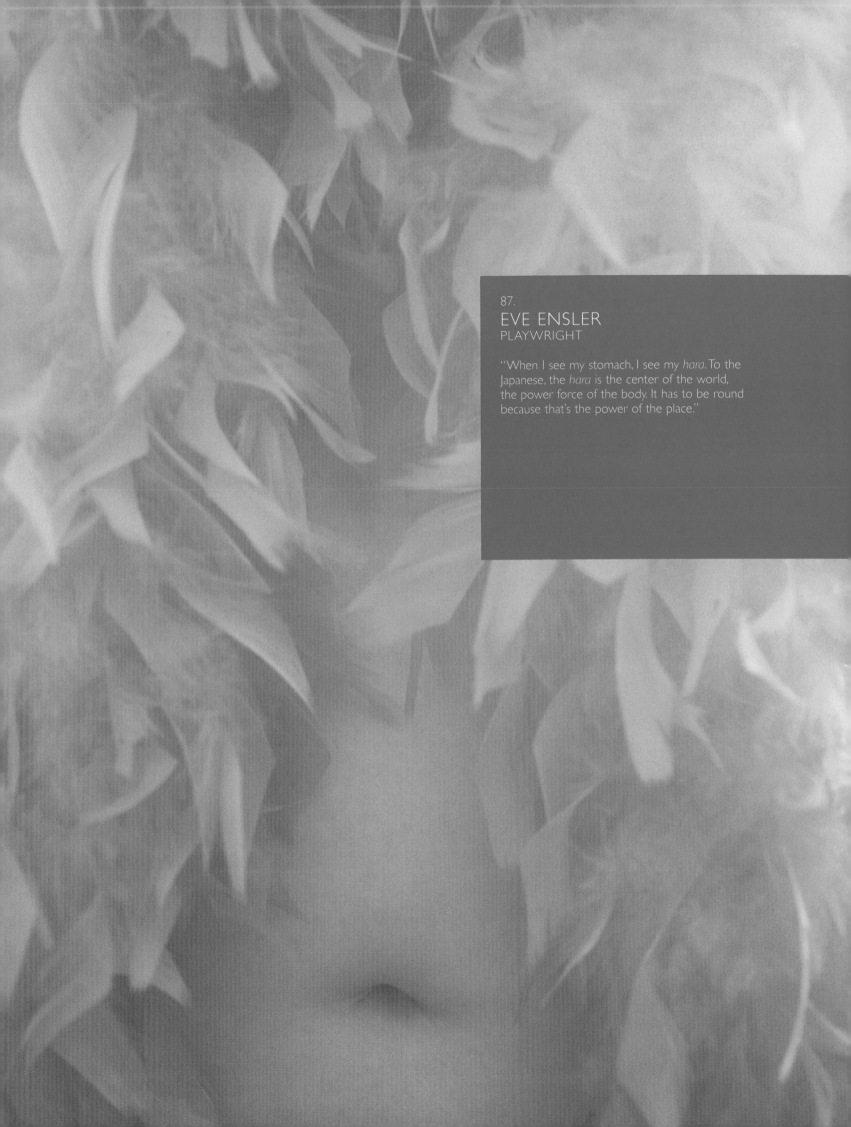

87.
EVE ENSLER
PLAYWRIGHT

"When I see my stomach, I see my *hara*. To the Japanese, the *hara* is the center of the world, the power force of the body. It has to be round because that's the power of the place."

space between eyebrows

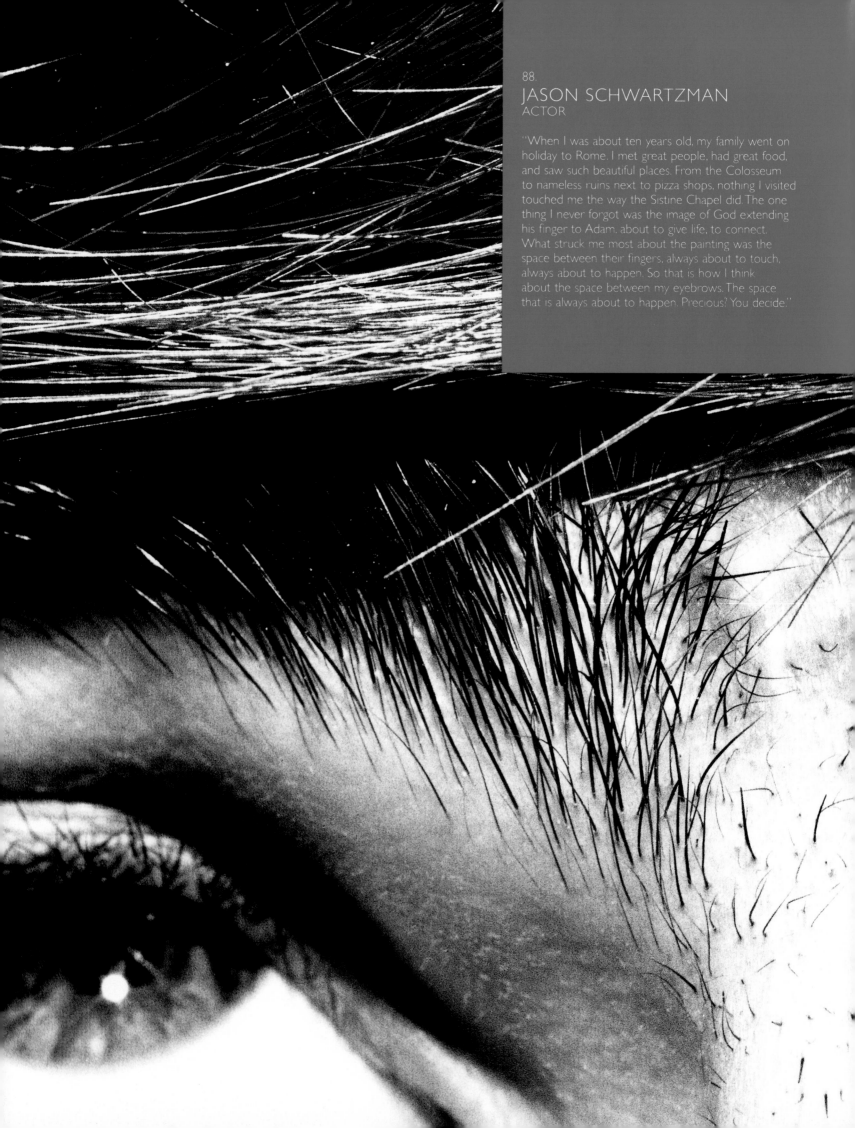

88.
JASON SCHWARTZMAN
ACTOR

"When I was about ten years old, my family went on holiday to Rome. I met great people, had great food, and saw such beautiful places. From the Colosseum to nameless ruins next to pizza shops, nothing I visited touched me the way the Sistine Chapel did. The one thing I never forgot was the image of God extending his finger to Adam, about to give life, to connect. What struck me most about the painting was the space between their fingers, always about to touch, always about to happen. So that is how I think about the space between my eyebrows. The space that is always about to happen. Precious? You decide."

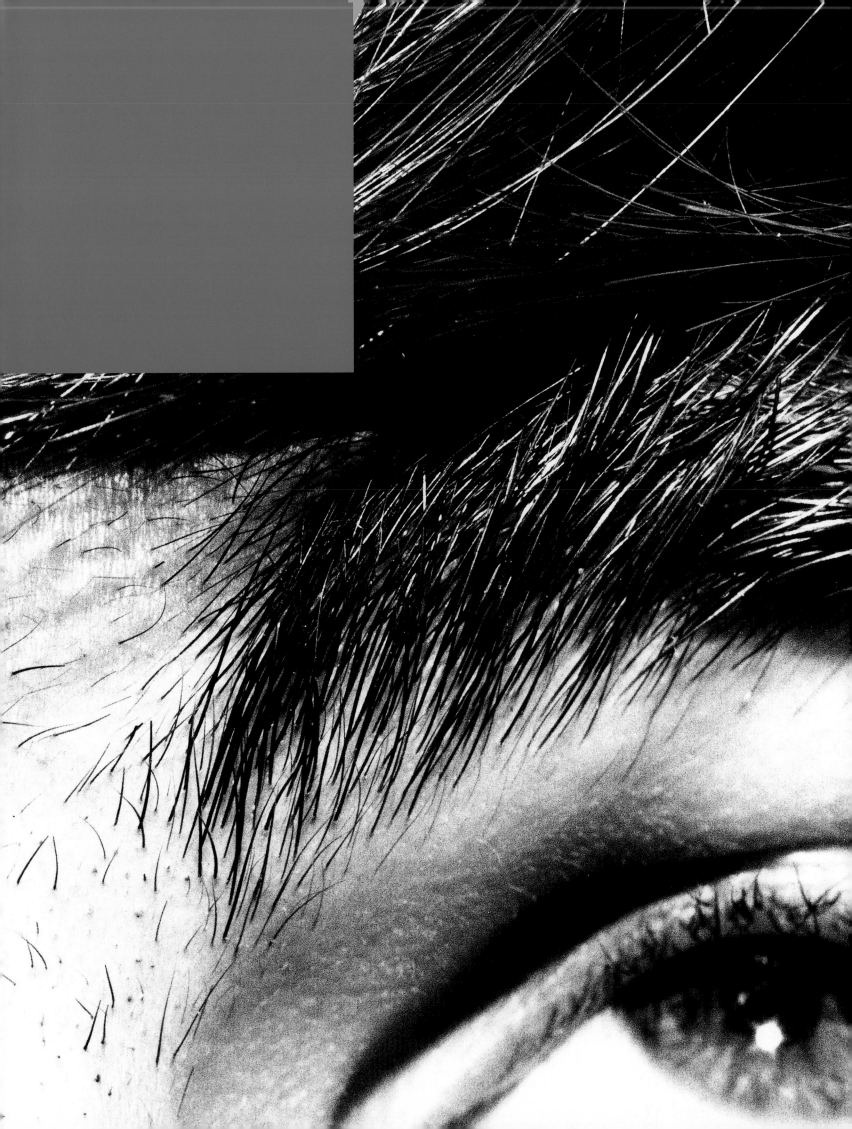

feet

tattoo

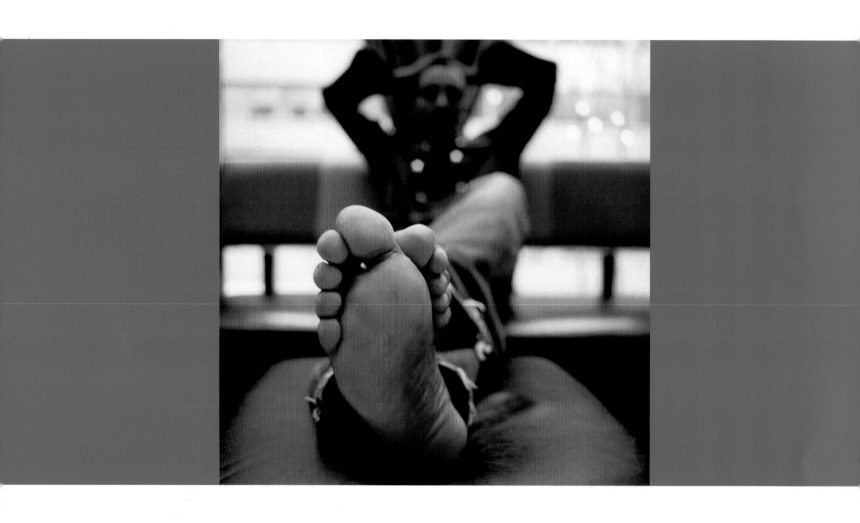

89.
MARCUS SAMUELSSON
CHEF

"As a chef, you always have to think on your feet."

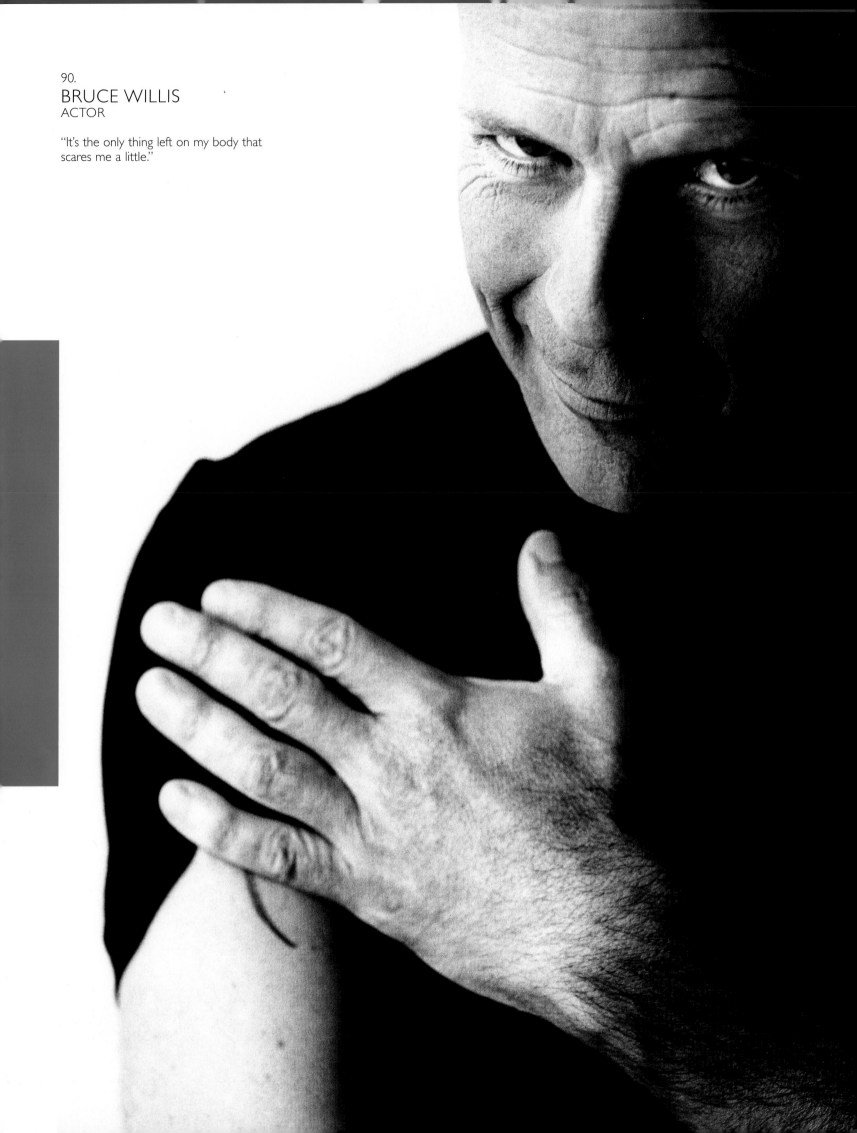

90.
BRUCE WILLIS
ACTOR

"It's the only thing left on my body that
scares me a little."

eyes

eyelashes

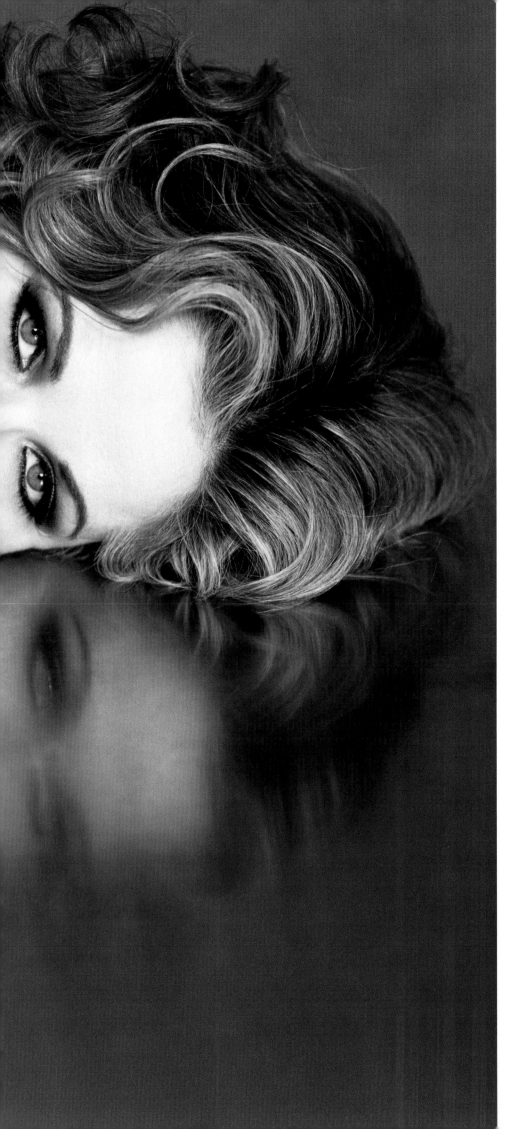

91.

RENÉE FLEMING
OPERA SINGER

"If someone turned on a CD of an aria and left it to play alone in the woods, would it make a sound? I love recording, but when my voice goes off into the world without me, I never know exactly how it is received. The reports always come later, after the listening, which is a different moment entirely than the moment of actually hearing the music. As a singer, there is nothing as rewarding as the opportunity to watch the audience hear. I can actually see the nuance of the music reflected back onto their faces. I can see which note thrills and which note breaks their heart. Live performance is an interaction: The emotions of the audience pour into me, and I add that feeling to my voice, which is then given back to the listener. It is the reason why every opera, every recital, is a completely unique experience. Without my eyes, I'd miss the most thrilling part of singing, which is seeing, which is why I'm very partial to my eyes."

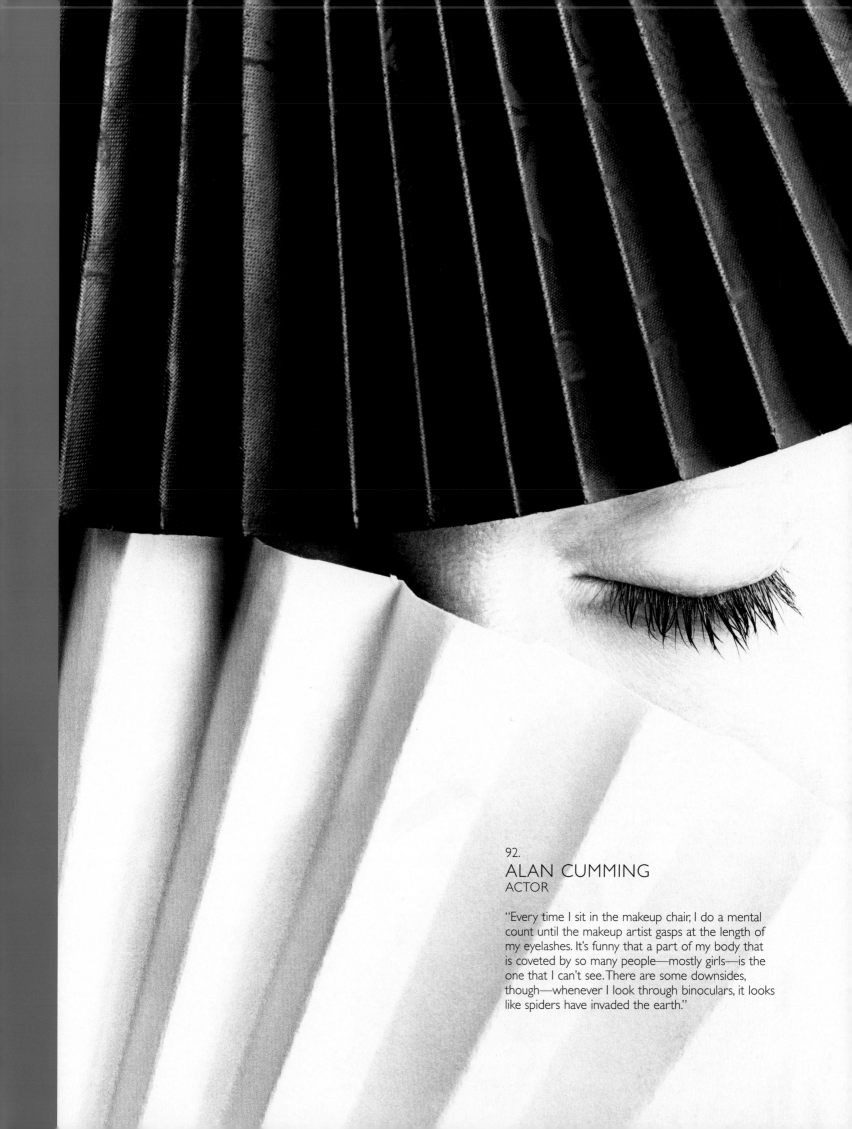

92.
ALAN CUMMING
ACTOR

"Every time I sit in the makeup chair, I do a mental count until the makeup artist gasps at the length of my eyelashes. It's funny that a part of my body that is coveted by so many people—mostly girls—is the one that I can't see. There are some downsides, though—whenever I look through binoculars, it looks like spiders have invaded the earth."

elbow

ass

93.

PAULY SHORE
ACTOR

"My elbow, because it's long and hard."

94.
ELLEN DEGENERES
COMEDIAN

"Because sometimes you just need a good shot in the ass."

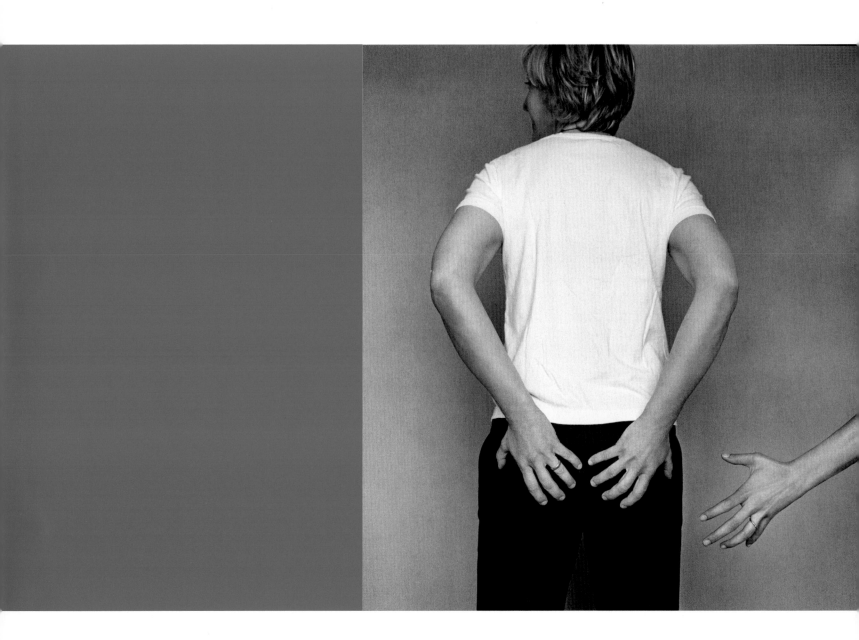

94.
ELLEN DEGENERES
COMEDIAN

head

hands

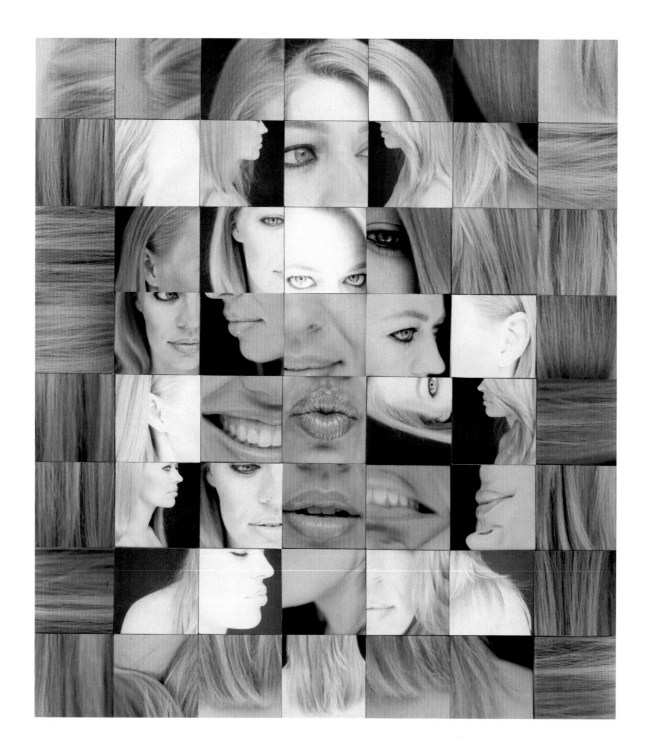

95.

JERI RYAN
ACTOR

"My head—because I see the people I love in
every feature. My eyes are my son's eyes.
It's my mother's bone structure and her nose,
my dad's ears and mouth, my brother's hair
and smile…."

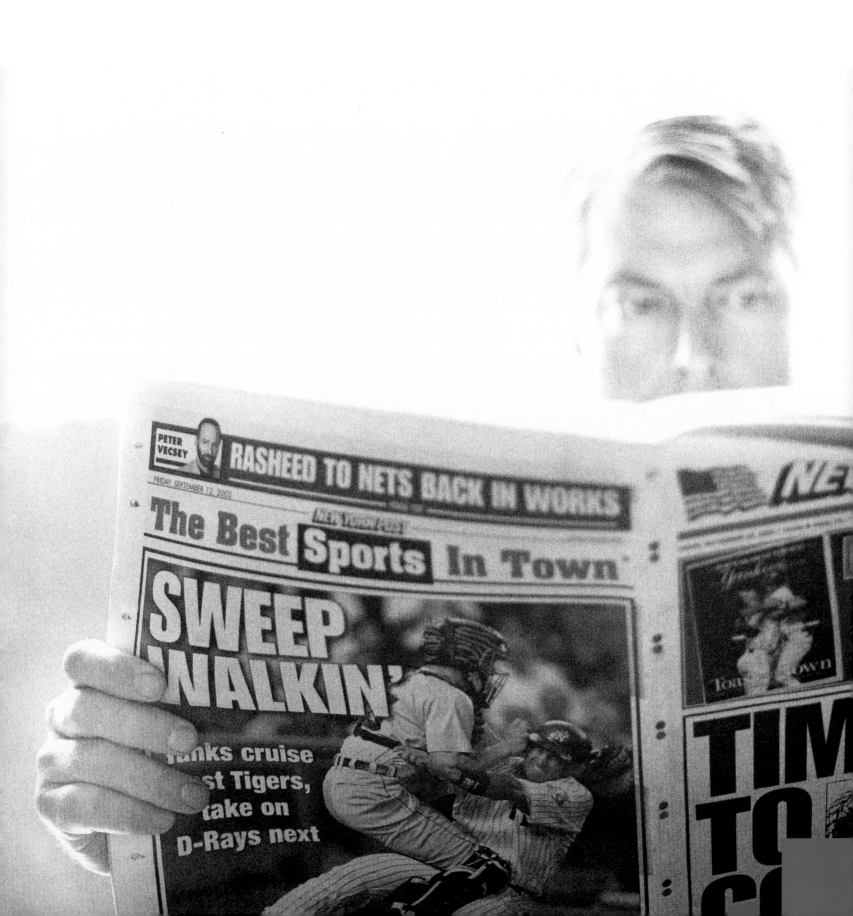

96.
RICHARD JOHNSON
NEW YORK POST GOSSIP COLUMNIST

"It's great having ten fingers, though I only need two."

feet

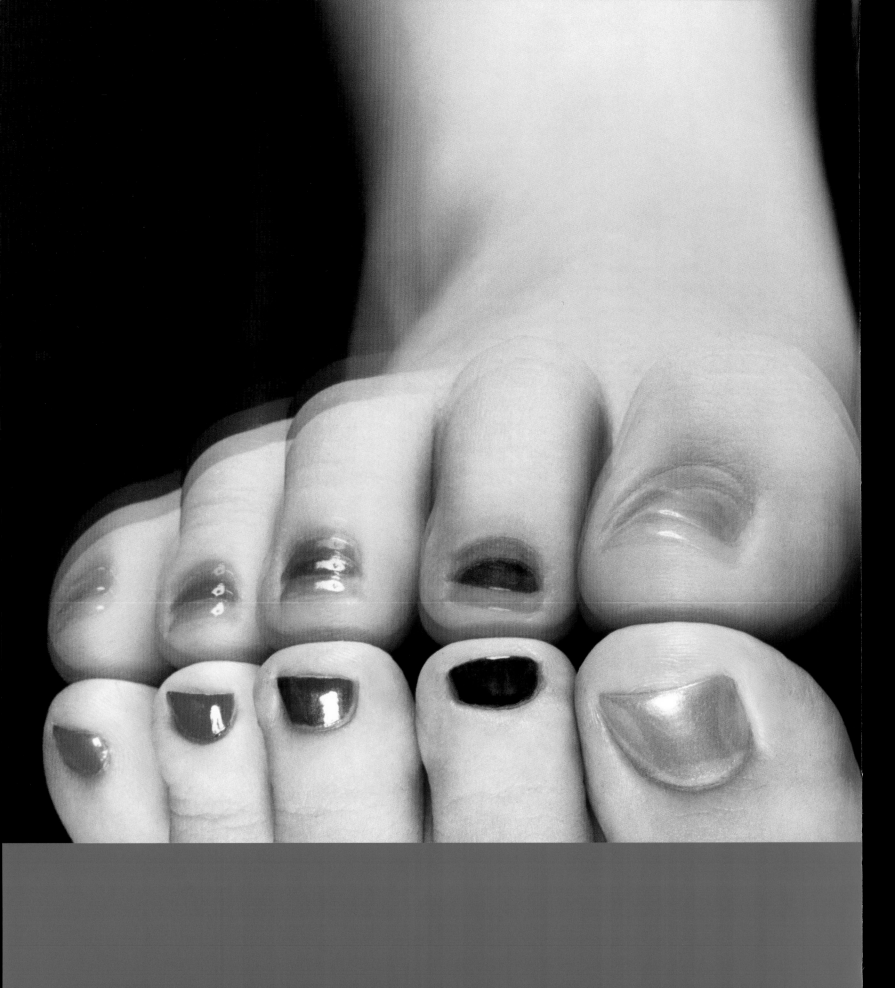

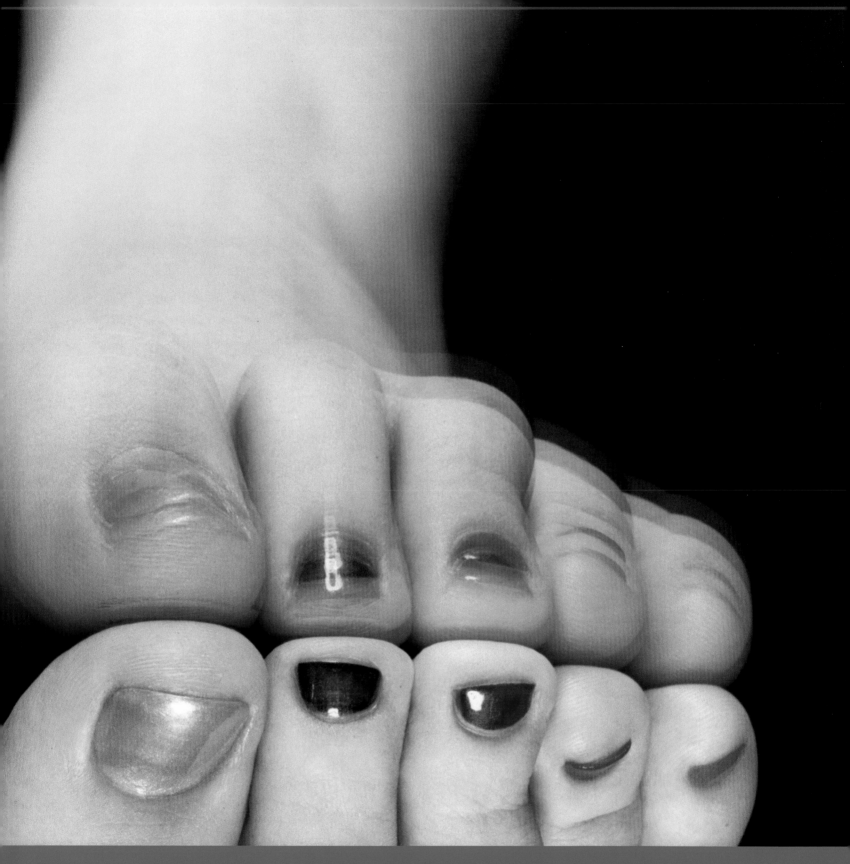

97.
EMMA PARRY
SCHOOLCHILD

"They remind me of when I was really little."

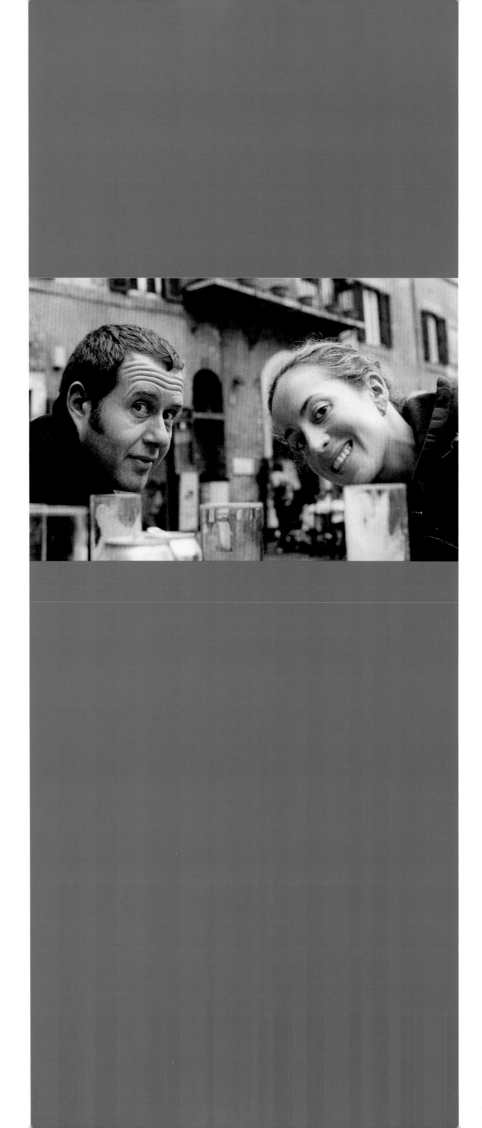

NIGEL PARRY AND
MELANIE DUNEA
PHOTOGRAPHED BY
EMMA & JACK PARRY

THANK YOU

Geoff and Pam Katz; if you didn't believe in us no one would

Justus Oehler at Pentagram for his beautiful design

Jennifer Stanek and Hugo Reyes who ate, drank, and slept Precious

Daniel Power and Craig Cohen and the rest of the posse at powerHouse Books

The Starlight Children's Foundation

Alina, Chris, Paige, and Khaled and the Industria crew for always saying Yes!

Gregg Delman, Fred Chatterton, Maggie Goudsmit, and Dawn Sticklor and all of the other overworked and underthanked Photo Assistants

Caroline Dejean and Devin Melillo, our trusty right hands, without you we couldn't find anything

Everyone at CPi for dealing day-to-day with our every need

Adam Nelson and his crew at Workhouse Publicity

Jennifer Crawford, Christine Hahn, Denise Feltham, and Anne Madden for wrangling clothes and props at the last minute (as usual)

Nikki Wang, Katrina Borgstrom, and Andre Drykin— star groomers

Uta Tjaden for all her hard work

Special thanks to Fuel for its fabulous service. Thank you Ed Weinstock, Jerid O'Connell, Paul Judice, and Louis Servedio-Morales

Allison Seed our ally since the beginning

Anjelica Canales, Fredrika Edwards, Dustin Horowitz, Hali Lee, Gregg Link, Doug Scott, and Stephanie Rudnick for subject gathering

Special thanks to all of the Subjects, their Publicists, Managers, and Personal Assistants who gave their Precious time

Emma, Jack, Doreen, George, Mary, and all of our friends and families thanks for understanding....

PRECIOUS

© 2004 powerHouse Cultural Entertainment, Inc.
Photographs © 2004 Melanie Dunea
Photographs © 2004 Nigel Parry

Published in the United States by powerHouse Books,
a division of powerHouse Cultural Entertainment, Inc.
68 Charlton Street, New York, NY 10014-4601
telephone 212 604 9074, fax 212 366 5247
e-mail: precious@powerHouseBooks.com
website: www.powerHouseBooks.com

First edition, 2004

Library of Congress Cataloging-in-Publication Data:

Dunea, Melanie.
 Precious : photographs / by Melanie Dunea and Nigel Parry.
 p. cm.
 ISBN 1-57687-210-6
 1. Celebrities--Portraits. 2. Portrait photography. 3. Dunea, Melanie. 4. Parry, Nigel. I.
Parry, Nigel. II. Title.

 TR681.F3D88 2004
 779'.2'092--dc22

 2004044724

Hardcover ISBN 1-57687-210-6

Separations, printing, and binding by Amilcare Pizzi, S.p.A. Milan

Book design by Justus Oehler, Pentagram Design

A complete catalog of powerHouse Books and
Limited Editions is available upon request; please call,
write, or see what else is precious on our website.

10 9 8 7 6 5 4 3 2 1

Printed and bound in Italy